To my mother, CAROLYN CORY PETERSON, who has always known the meaning of charity.

ACTS OF CHARITY

MARK PETERSON

ACTS OF CHARITY

PHOTOGRAPHS BY MARK PETERSON

EDITED BY CARMEN DUNJKO
INTRODUCTION BY PHILIP WEISS

powerHouse Books NEW YORK, NY

FOR FOURTEEN YEARS **MARK PETERSON** HAS BEEN TRAINING HIS LENS ON NEW YORK CITY'S HIGH SOCIETY, CATCHING IT IN THE ACT AND ART OF GIVING. THIS SOCIAL DOCUMENT PROVIDES AN INTRIGUING GLIMPSE OF WHERE AND WHEN WEALTH CHANGES HANDS, CAPTURING THE IRONIES INHERENT IN THE WORLD OF FUND-RAISING AS WELL AS THE HUMOR AND CREATIVITY THAT EMERGE THROUGH THE STAGING OF GRAND CHARITABLE EVENTS.

ABOUT THE PHOTOGRAPHS:

ABOUT TEN YEARS AGO, Mark Peterson and I were walking around Central Park when he mentioned that he had recently met Brooke Astor. It wasn't the kind of thing I expected from him. "The socialite?" I asked. Mark nodded. "Mrs. Astor," he said with respect in his voice. He'd been assigned by *The New York Times* to follow her around. He had been to her apartment and accompanied her all around town in her chauffeured car. And I imagined the deferential way that Mark could be, his kind expression and quiet Minnesotan humility, a lot of mellow uh-huhs and getting out of people's way, all the while carrying thirty-six bear traps inside his Canon.

ONE DAY, Brooke Astor and Mark traveled together to a school in Harlem ("See, it's important to Mrs. Astor to go to every place she gives her money to.") and she stepped out of the car wearing long gloves, a Chanel suit, a hat, pearls, the whole immaculate ensemble; easily $10,000 worth of clothes and jewelry. To the schoolchildren who witnessed this spectacle she might as well have been a Martian emerging from a space capsule, and so they watched awestruck as she shuffled into the school library where the staff stood ready to receive a check for $5,000.

To them it was a big check, and the principal was immensely grateful, as the library was in desperate need of more books. She thanked Mrs. Astor humbly, almost bowing to her. And then Mrs. Astor asked whether the kids still read that book she had loved as a child, *Little Black Sambo*. An awkward silence fell over the room, but the principal handled it deftly: "No, I'm afraid we don't have that book here anymore, Mrs. Astor." The visitor's exquisite demeanor didn't alter in the slightest at this news, and she teetered her way out to the waiting limousine, ready to be delivered back into the social stratosphere, thirty blocks away, on the Upper East Side.

I laughed hard at this story, though I wasn't entirely sure where Mark was going with it. Then he asked me if I could do him a favor. Mark had never asked me for anything. "Of course," I said, "What do you need?" "Get me into society parties. I'm interested in that world she's in."

And with that began a decade-long journey that would take Mark through the exclusive world of high-society philanthropy, into the preferred clubs and lavish parties, the benefits, launches, and charity balls where the well-off gather to socialize and to give—a journey that has resulted in this book. *Acts of Charity* presents a body of work that pulls back the curtain on a world most of us rarely get to see, one where dogs are sometimes as carefully dressed as people and where each celebrity-laden event attempts to outdo the last.

At the time of his encounter with Mrs. Astor, Mark was himself living at the edge of Harlem, almost as far removed from Manhattan society as the children in that school, a restive documentary photographer slowly making his way up the journalistic ladder. We would often run into each other around town—at a Hüsker Dü concert, or down on the courthouse steps where he'd be covering municipal affairs. Back in Minnesota he started out running a neighborhood newspaper after he met a United Press International newswire guy and showed him some photographs. The UPI guy saw something in the work and said Mark should fill in for him while he was on vacation, lending him an old Olympus that had been to Vietnam and back.

It is not unusual for creative people to see something fresh in Mark's work, a sensibility both pure and vibrant and often slightly disquieting. Later, after moving east to New York, he covered haute couture for a variety of European publications, hung out in Paris, shooting Karl Lagerfeld or Karen Mulder, and impressed his editors with his eye for unusual

detail. I thought that maybe Mark was going to be seduced by fashion, but it didn't happen. Fashion did not involve him enough; it lacked a moral focus and complexity. He felt more alive shooting a halfway house than the House of Dior—and indeed was often rushing back to Minnesota to document a treatment center for the down-and-out.

There was also the fact that commercial fashion photography offered him little new opportunity visually. Fashion was a thoroughly documented world. It had already been done behind the scenes, in front of the scene, all around the scene, and the best fashion photography was not difficult to find—it was going past you down the street on the side of a bus. Instead, Mark would take a photographic journey through an entirely different course. And though I never did deliver on the promise to give him an entrée into New York society (and, unfailingly polite, he never brought it up again), he proved himself amazingly adept at gaining access to that realm and bringing back evidence of how the other half gives.

Seeing and being seen are integral parts of the modern philanthropic dance that Mark documents. While the Easter Parade was once New York's signal spring charity event, the Central Park Conservancy awards luncheon has lately replaced it. Mark's pictures of the conservancy's spring gala hint at the exclusive, rarefied nature of this annual occasion. Society women stop at the top of the Vanderbilt Gate steps to show off their hats, then descend, sometimes with a male escort, hoping to catch the eye of a photographer. You can see the strain on their faces, the need to maintain their poise and equilibrium while saying hello to as many people as possible over the next couple of hours. You will spot the famous and the privileged at every turn: Mary Boone seated with Katie Couric, Patricia Duff with Mrs. Bruce Wasserstein and Nicole Miller, Peggy Siegel with Blaine Trump,

while across the aisle Ivana Trump is seated with Amy Fine Collins of *Vogue*, who wears vintage Geoffrey Beene. One thinks back on the Easter Parade, which these upper-crust icons used to care about, and it is hard to imagine them mingling with the hoi polloi down on Fifth Avenue. After all, who has the time and patience for that? If a woman is going to don a $700 Patricia Underwood hat, what's the point in sharing the moment with some butcher's wife from Queens?

The ostentatious manner in which charity events often play out speaks to the underlying problem of merging social spectacle and virtuous intent. This is the downside of associating charitable giving with an "event." That people will give more when there is a party involved is understandable—we are social creatures, after all, and altruism and having a good time are not mutually exclusive.

But if people start to give only when there are tangible benefits on the side, like an opportunity to rub shoulders with the famous and powerful or being fêted on "Page 6," then we've got a problem. For what then becomes of the less glamorous charities, the ones that can't establish the necessary connections to the high-powered world of professional fund-raising? Who will support the less-than-chic causes that fail to ignite the imaginations of today's mega-party throwers and goers?

It is true that there are a lot of funny moments in this book; as funny as the Harlem principal's encounter with Brooke Astor. There are the dead-serious expressions of people in ridiculously silly outfits, the spontaneous hijinks of well-dressed party-goers cavorting in museum bathrooms, and the earnest determination of a gaggle of charity shoppers racing across an intersection, bent on shopping till they drop. What to make of an elegantly bedecked gentleman showing off his gaudy tie to a caged gorilla, as if an ape could bestow sartorial approval?

BUT YOU CAN'T GO VERY FAR into this world without feeling a tinge of unease. There's something a little unsettling about all this pomp and circumstance. It is not immediately clear who is at fault, or how things got this way, but the specific American idea of charity that Mark is exploring begins to feel needlessly opulent, and one doesn't have to be a card-carrying socialist to wonder whether there may be a more efficient way to redistribute all this wealth.

Look hard at these photographs and you'll find that we have come a long way from the traditional Biblical notion of charity, an idea rooted in a sense of moral duty and ascetic piety. Giving alms and doing good works were once things best performed quietly and in service to God. These days, charity is a big business, marketed and promoted like any other, and there is nothing quiet or humble about it. Volunteers have largely been replaced by charity event companies that compete for contracts, and outfits like The Celebrity Source that devote themselves to matching stars with causes. Want to have a star of Jennifer Lopez's caliber at your next charity gala? Expect to pay up to $250,000 for the privilege.

If blame can be assigned for this state of affairs, then point a finger squarely at the trickle-down economic policies of every Republican administration since Reagan. George Bush the Father may have wished for a thousand points of light, but the funds for placing books in public schools or for the preservation of Central Park or for breast cancer research or to fight AIDS were expected to come from wealthy individuals and private enterprise (who had been showered with tax breaks and other incentives). Is it really any wonder that our charitable organizations, cut adrift from an ever-shrinking public sector, would adopt the trappings of a market-driven business?

Let's not be too hard on ourselves, though: Americans are an incredibly generous lot, and gave $240.92

billion to charitable causes in 2002—a full 2.3 percent of the country's GDP. But as social gadfly Lewis Lapham once wryly noted, "No nation gives so much of its wealth to charity; No nation invests so much of its earned income in the buying and selling of status." He elaborated: "The nation's history could be written as a long argument between opposed enthusiasms, an argument alternating between episodes of avarice and generosity, between spasms of orgiastic spending and sudden withdrawals behind the parameters of guilt."

It is that complexity, that tension, that Mark's lens draws out; the twin pulls of guilt and pleasure, of altruism and selfishness commingling in the same frame. Here Mark has found a moral focus that the world of commercial fashion photography lacks. Mrs. Astor's attentiveness to her causes proved to be the exception rather that the rule—she at least showed up to see where her money was going while the power models and society matrons seem more interested in who's speaking to whom or who's wearing what.

MRS. ASTOR dedicated herself to "the alleviation of human misery," and determined to spend her foundation down to nothing. None of the socialites and tycoons in these pictures would make so antediluvian a faux pas as asking after Little Black Sambo—but none of them would deign to mix with the hapless recipients of their generosity, either. The people in this book are largely showing up for the pleasure of each other's and the guest celebrity's company. The halls are gilded, the parties exclusive and fabulous. Everyone can feel important.

—PHILIP WEISS

PART ONE : RISING TO THE OCCASION

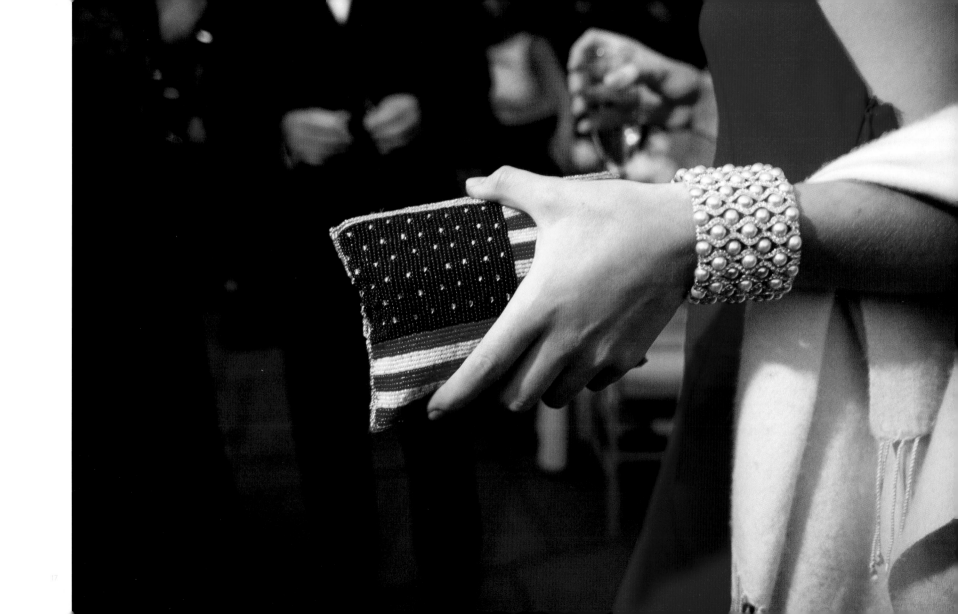

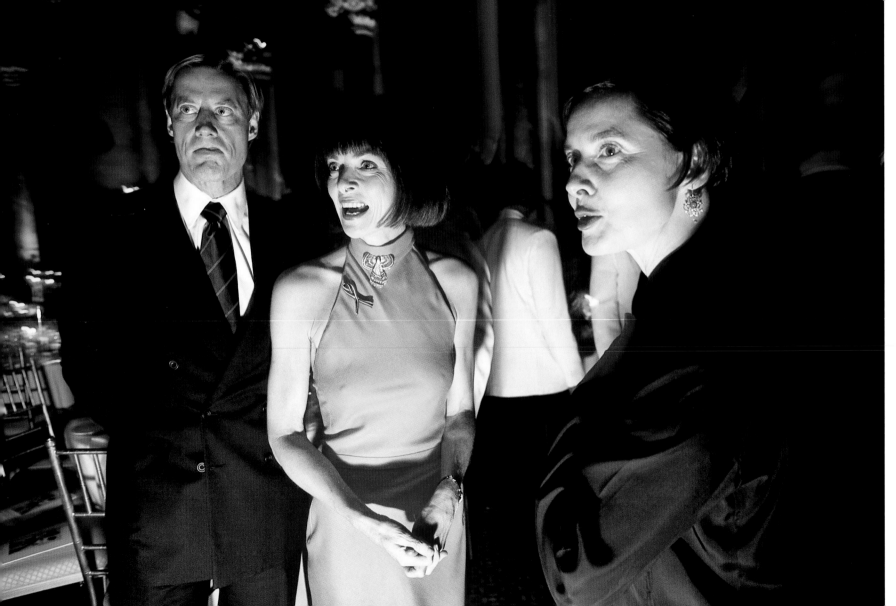

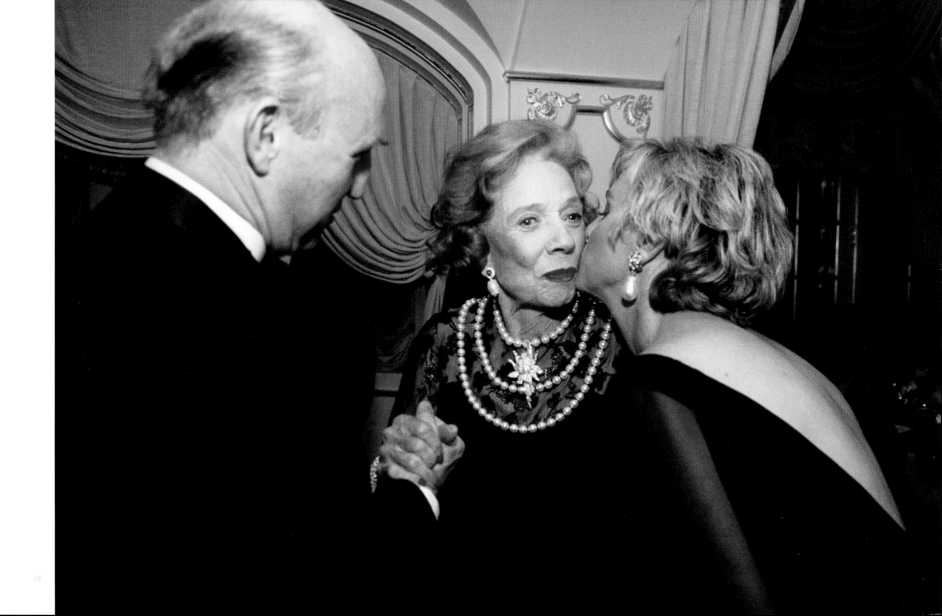

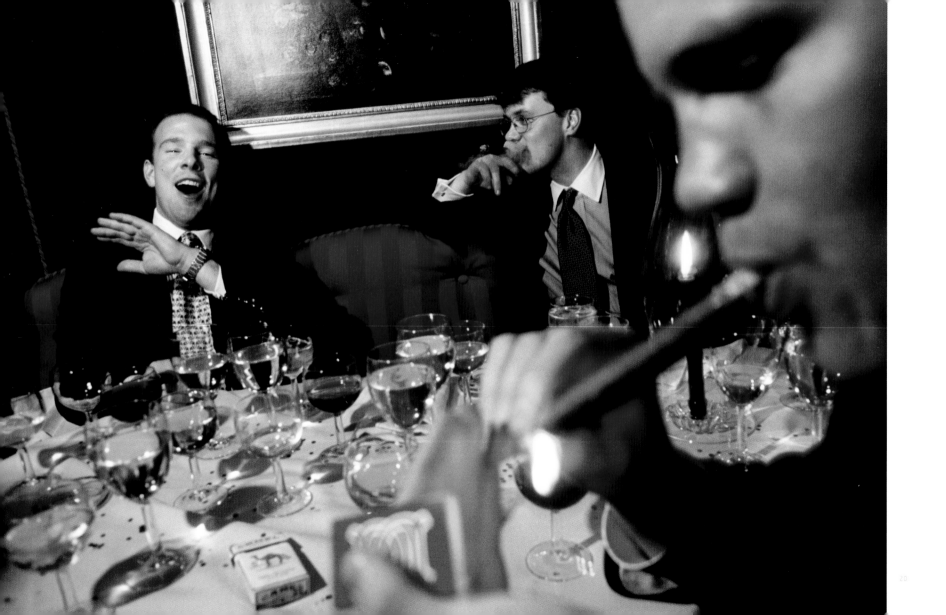

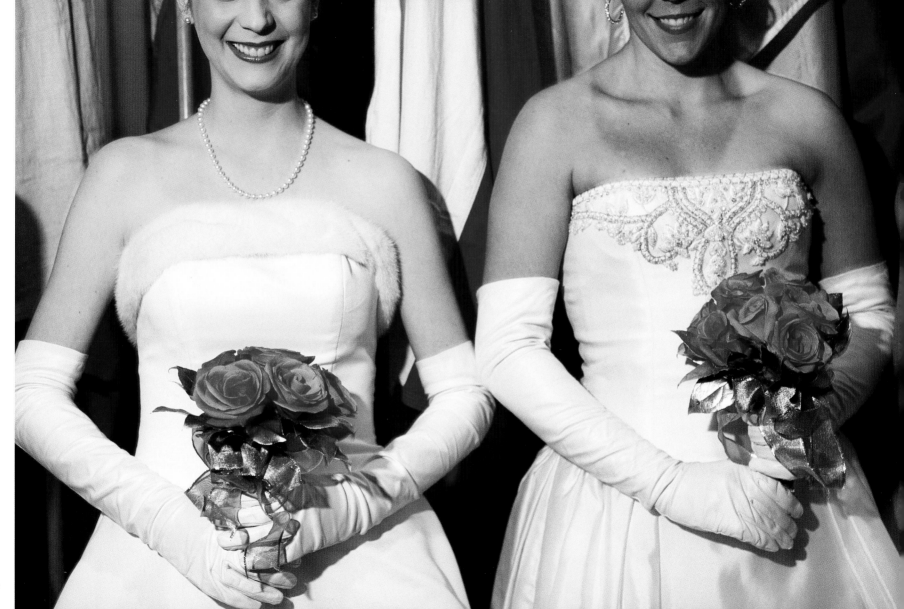

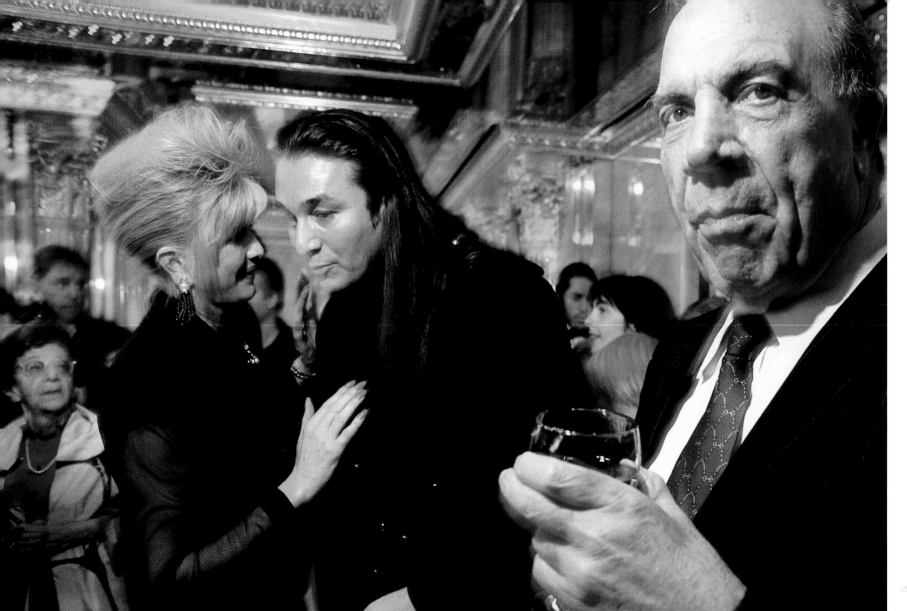

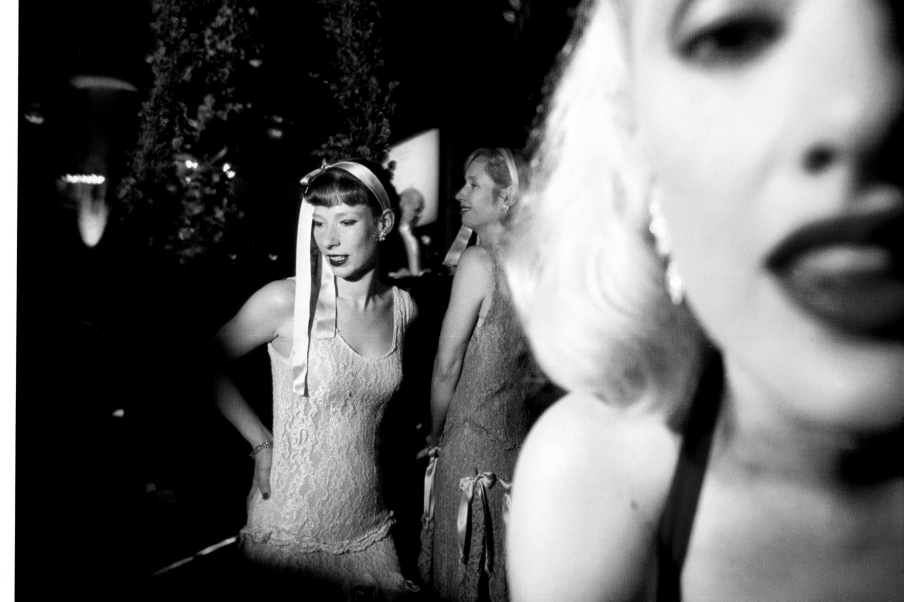

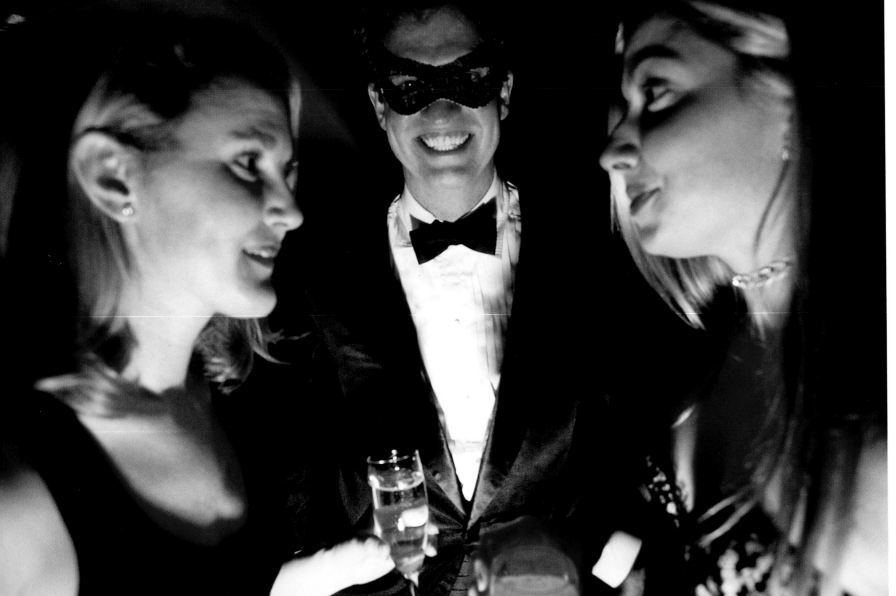

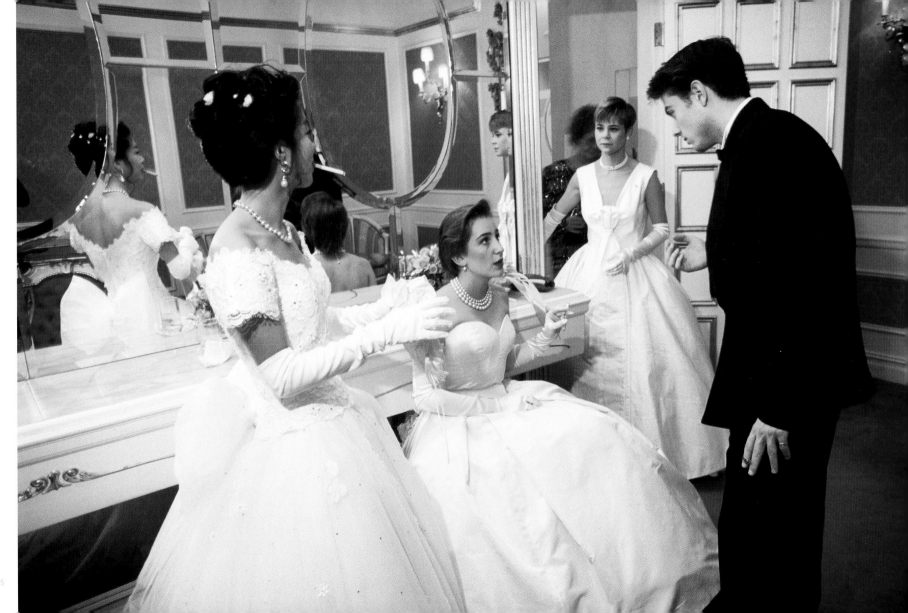

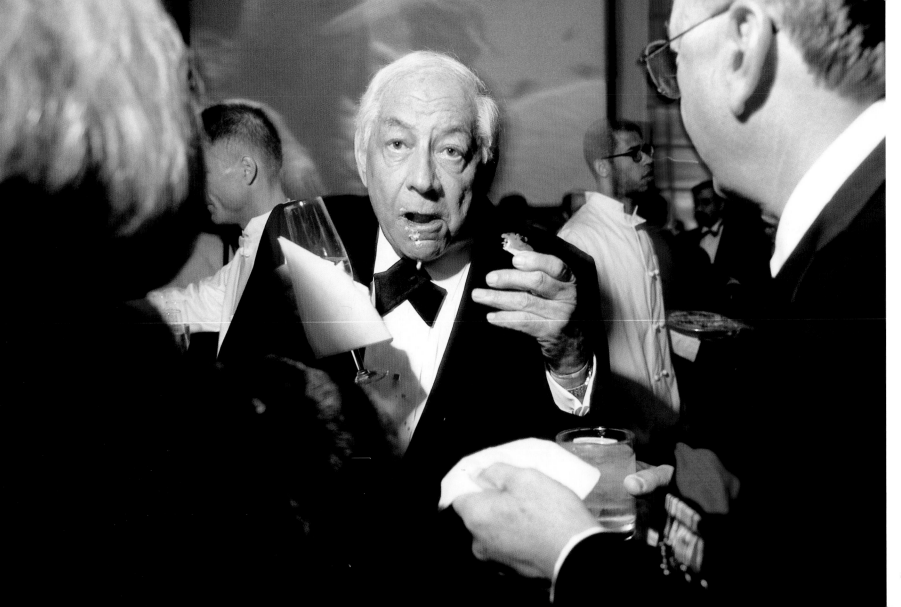

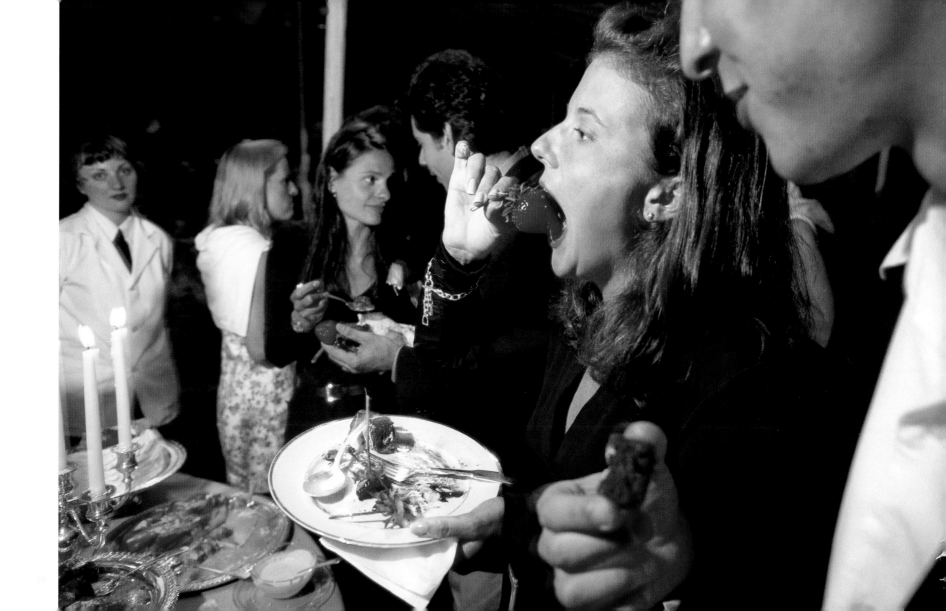

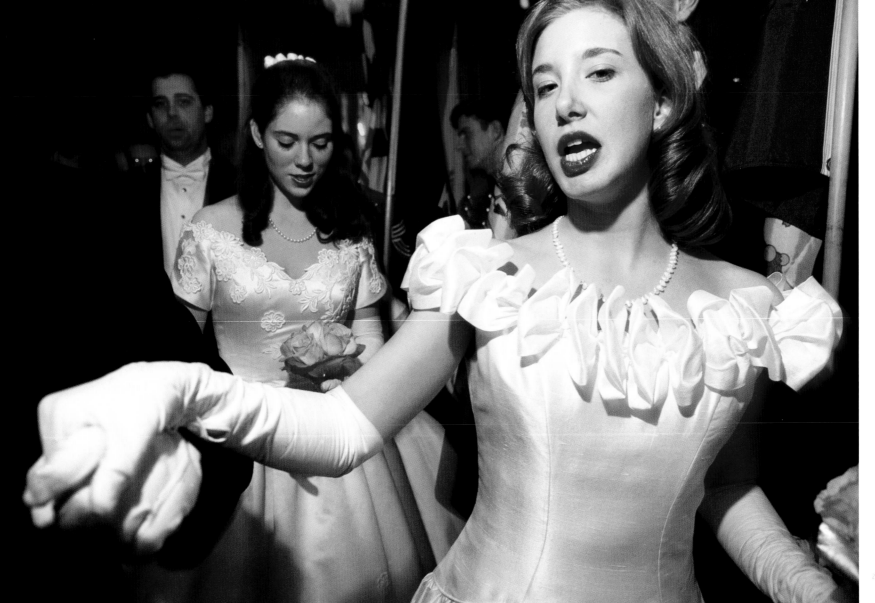

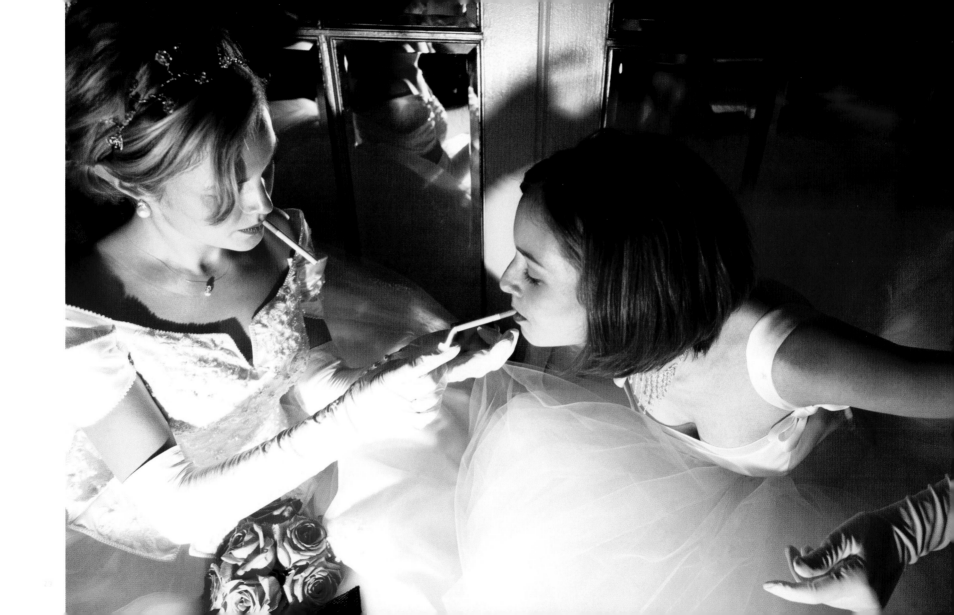

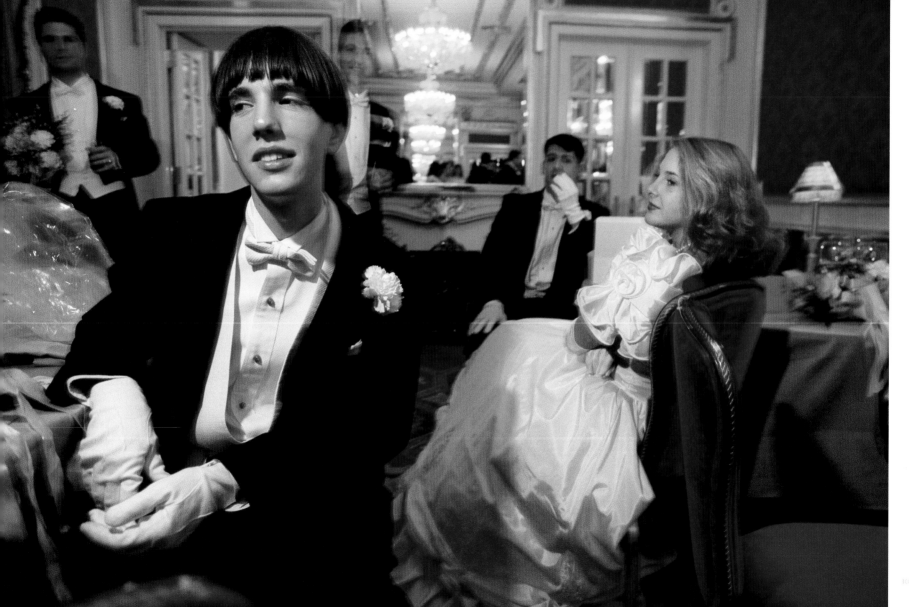

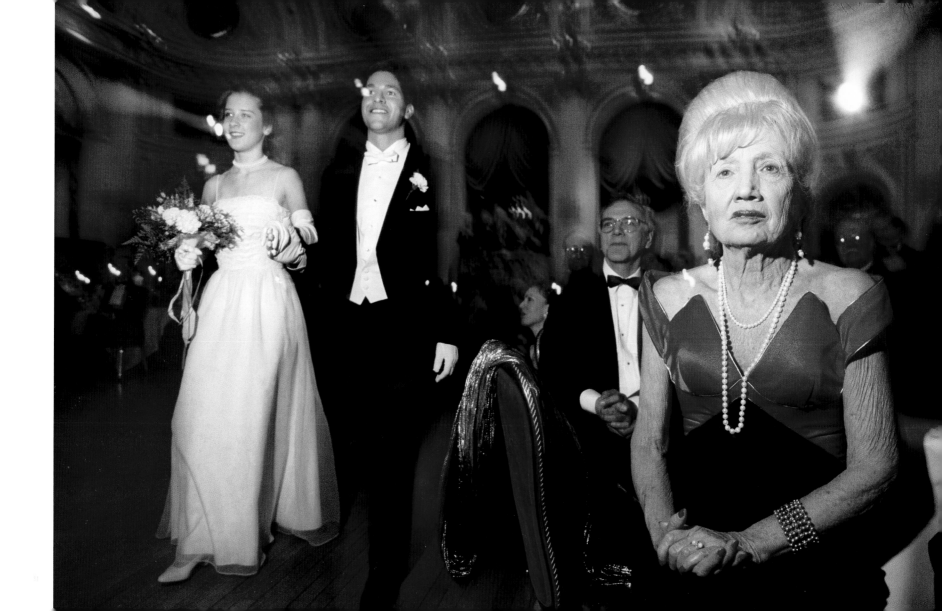

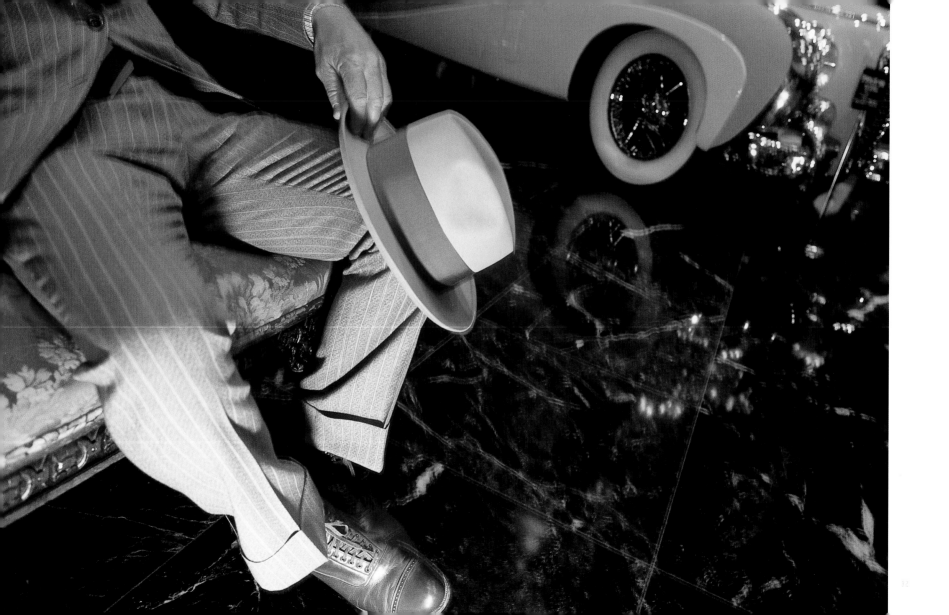

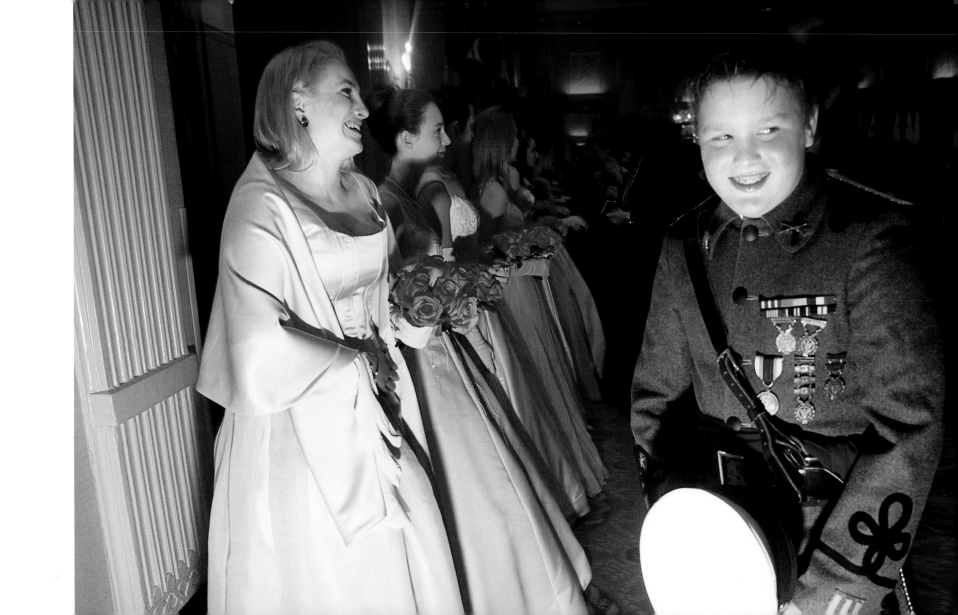

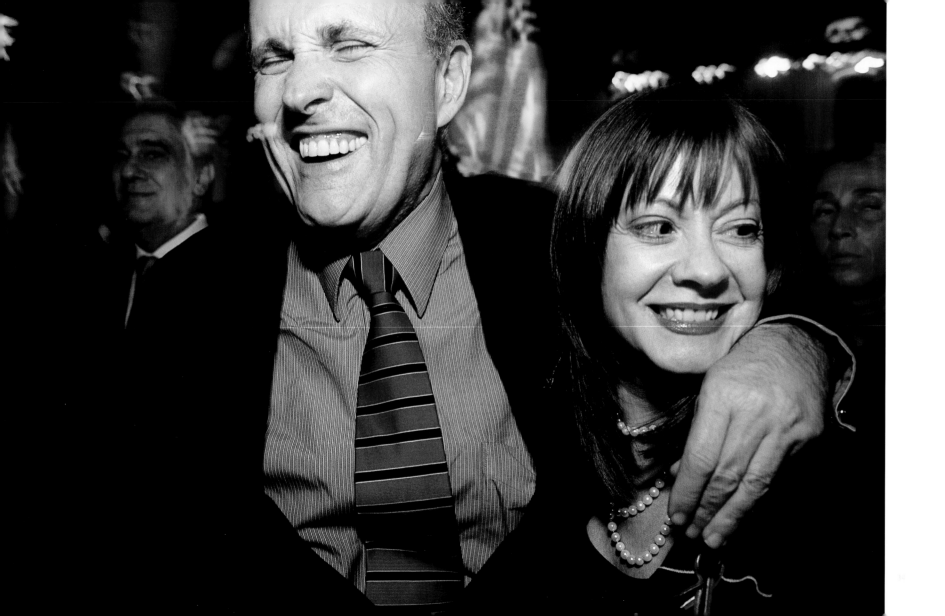

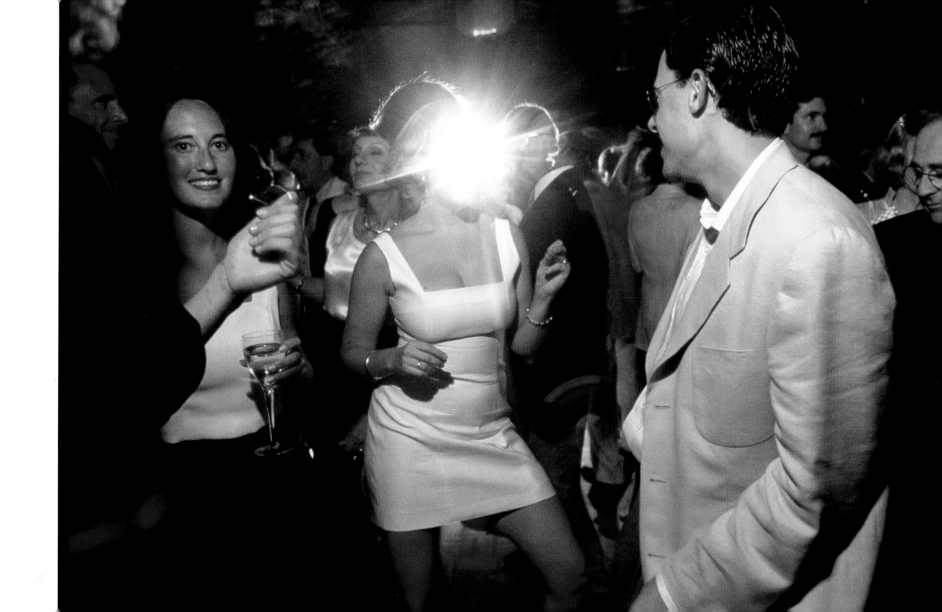

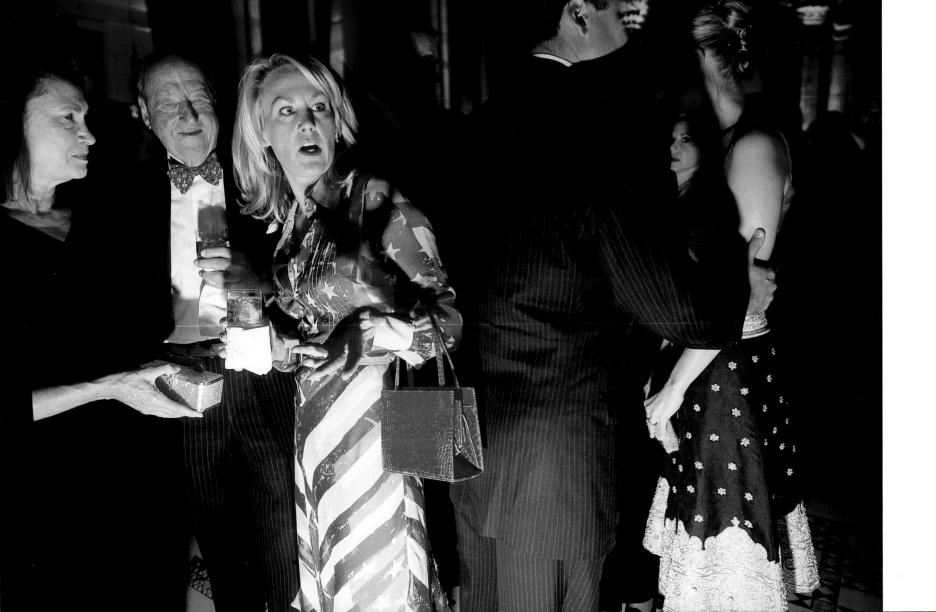

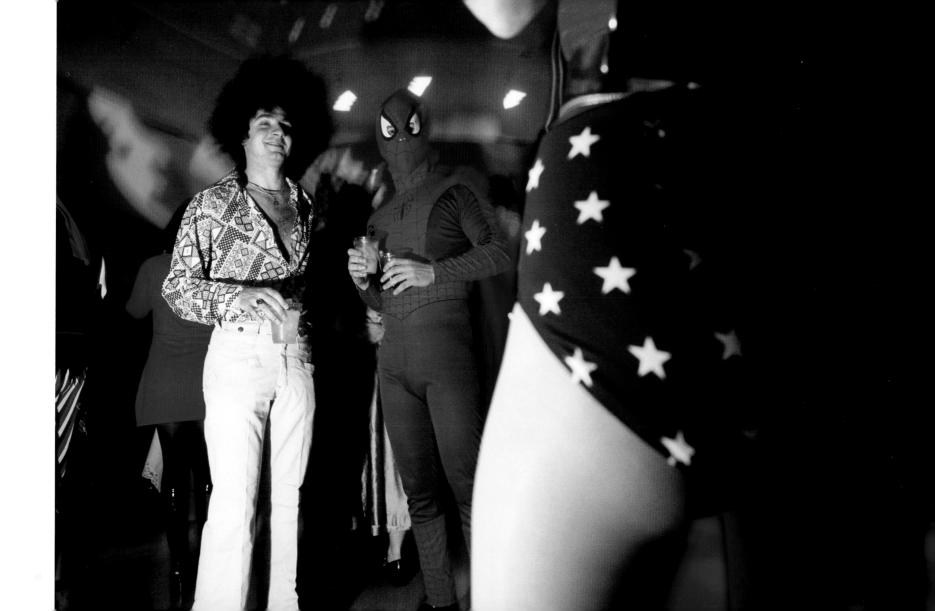

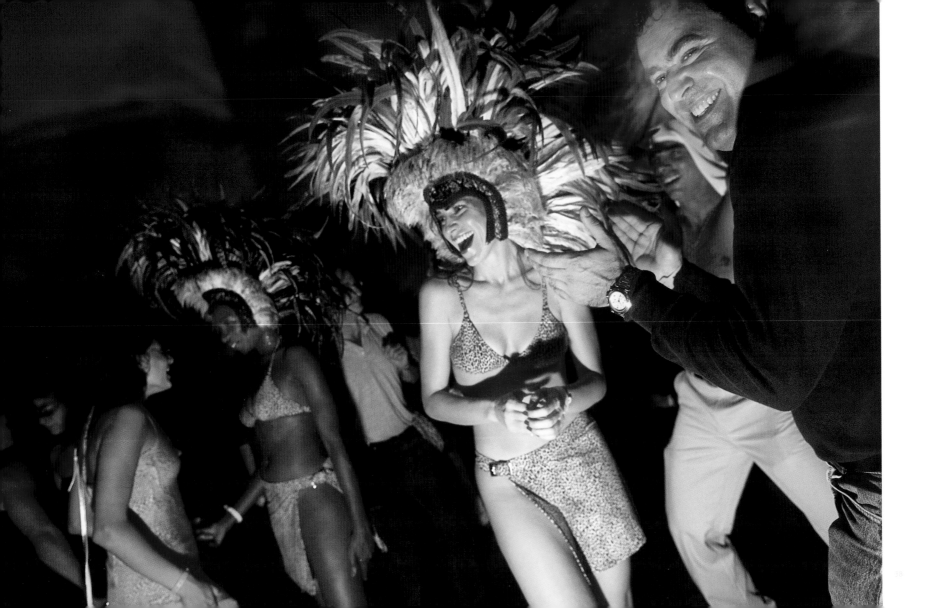

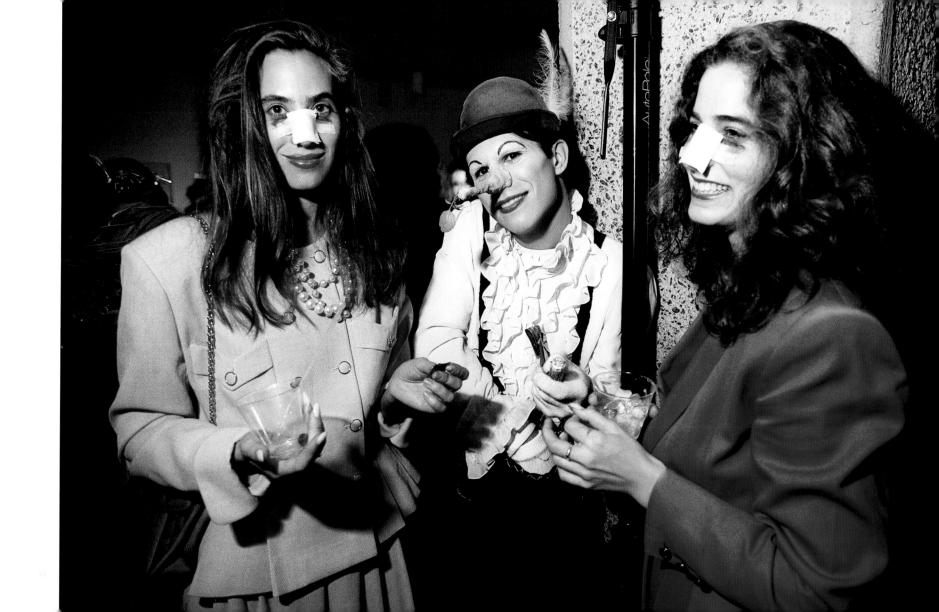

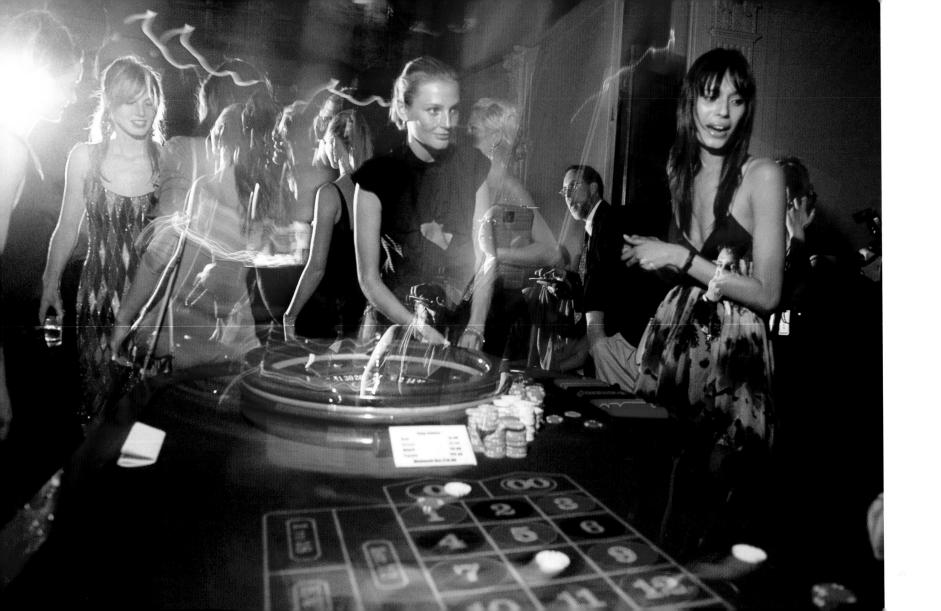

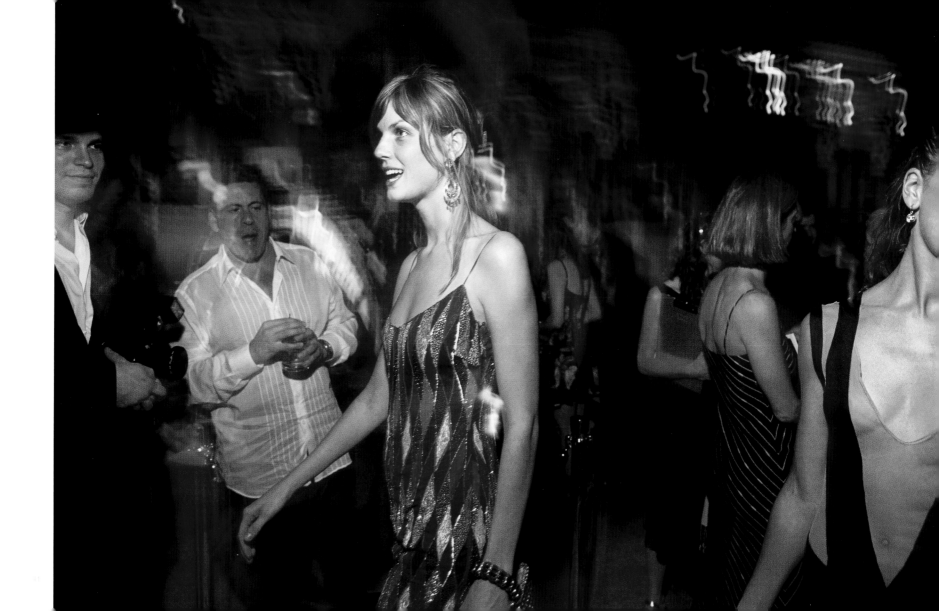

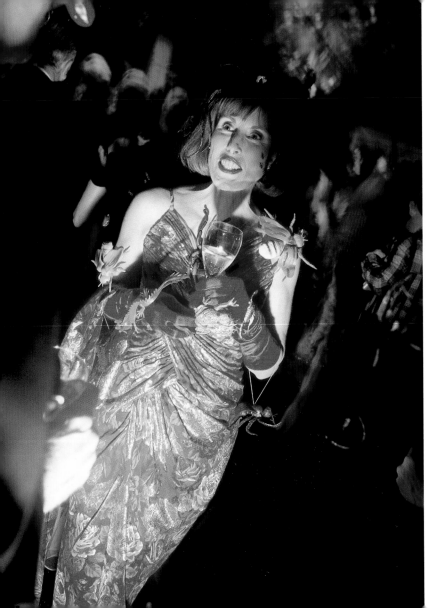
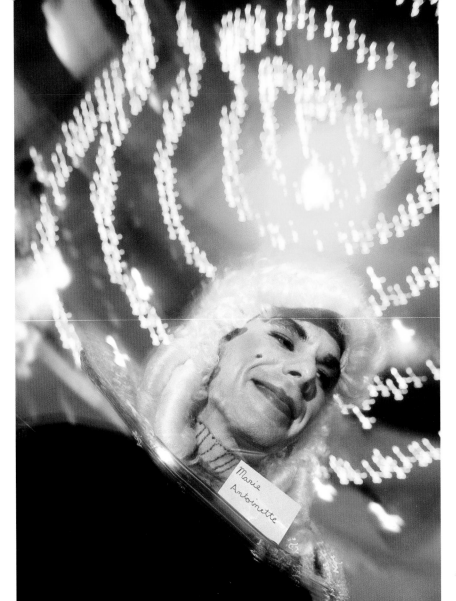

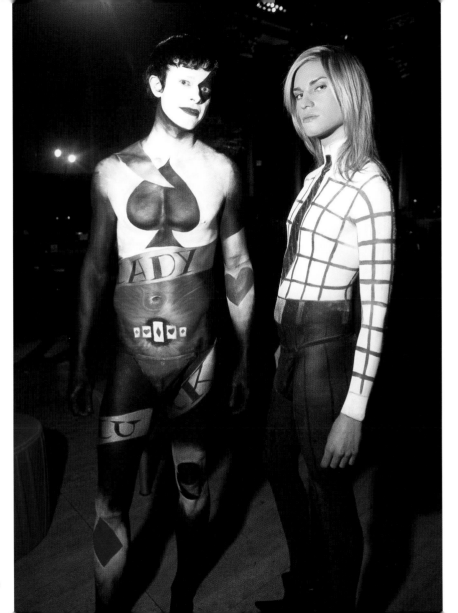
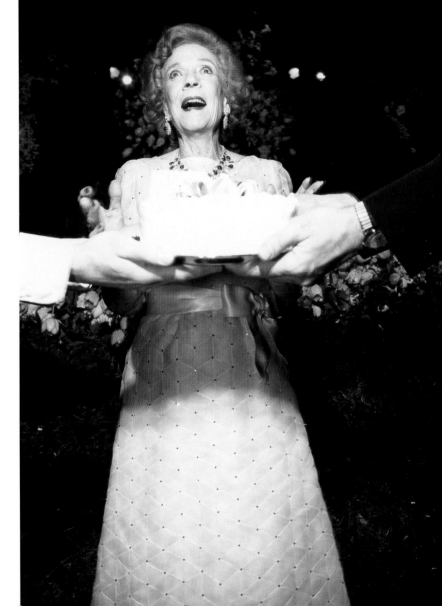

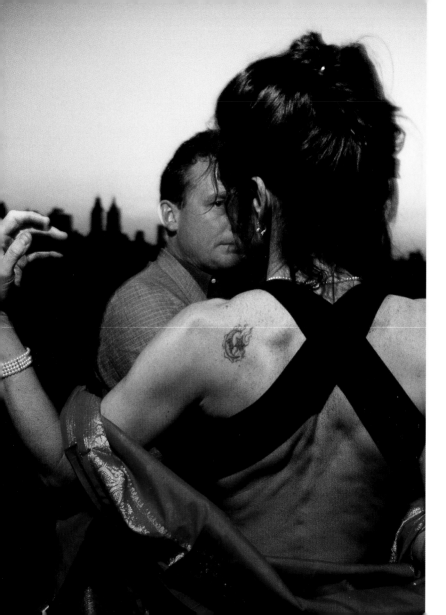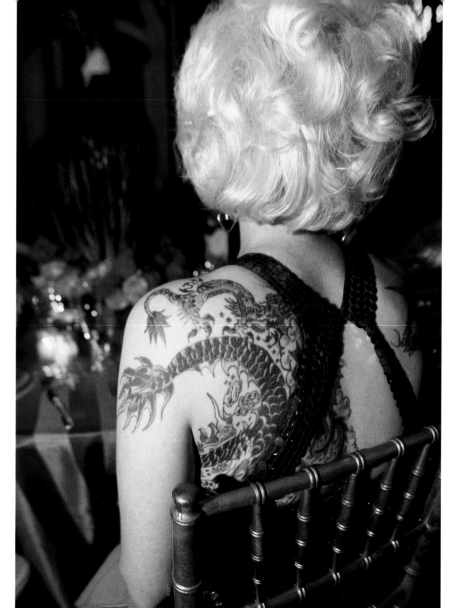

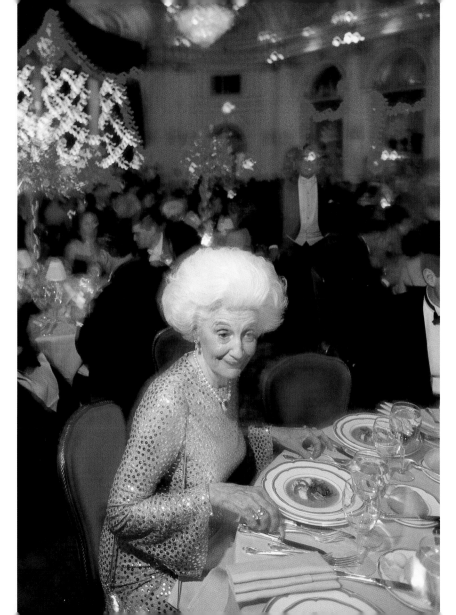
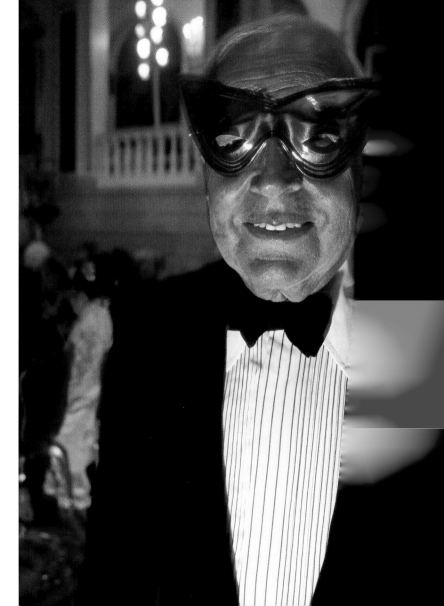

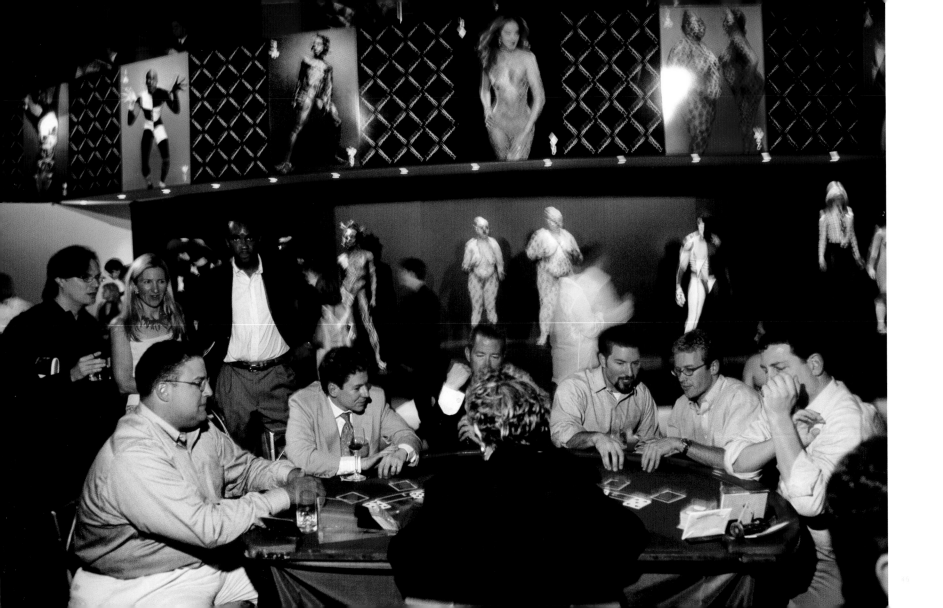

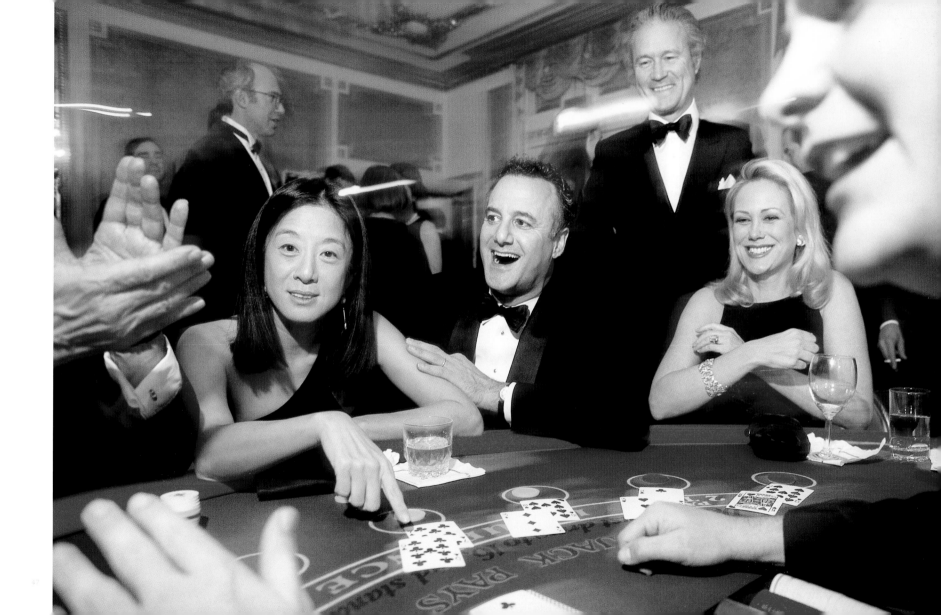

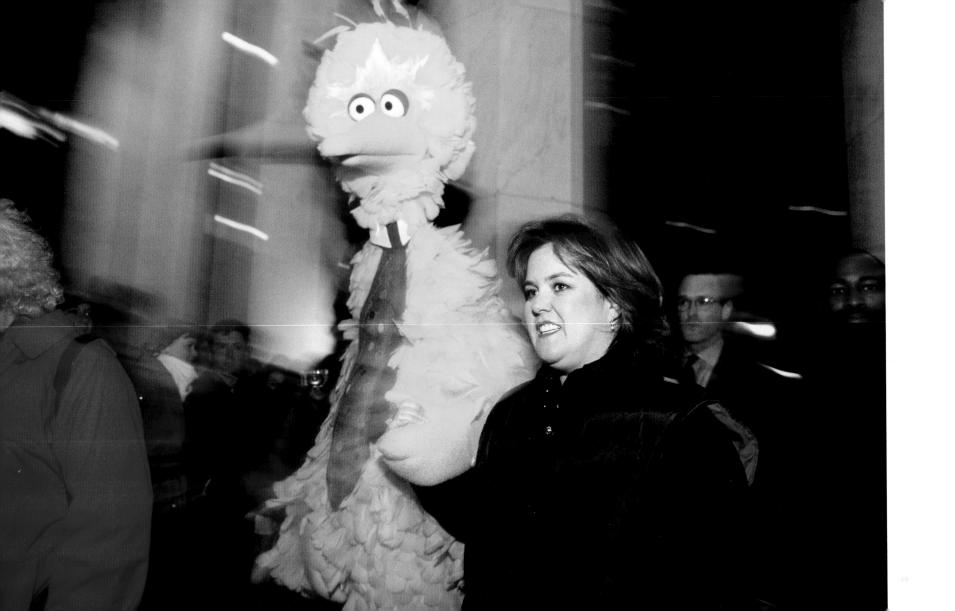

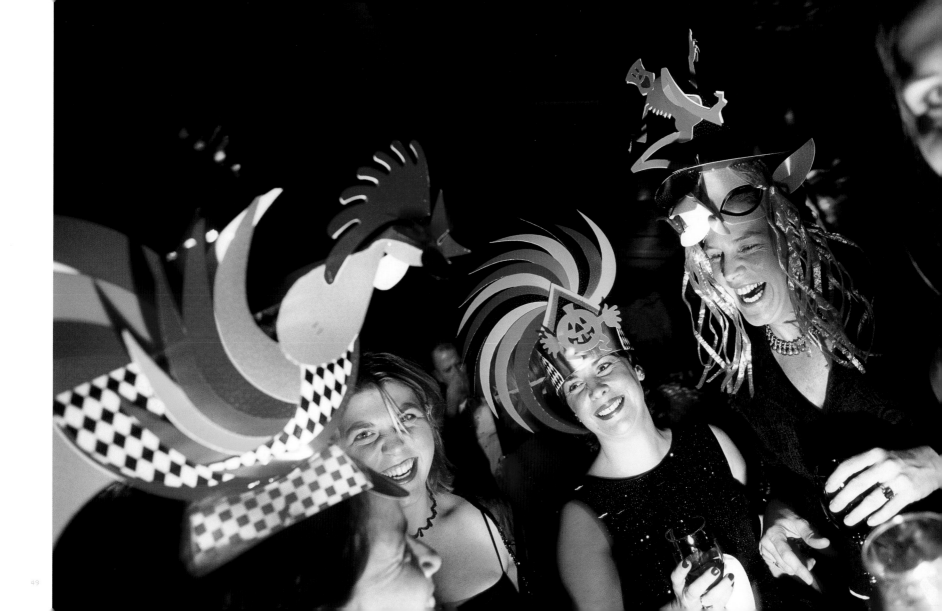

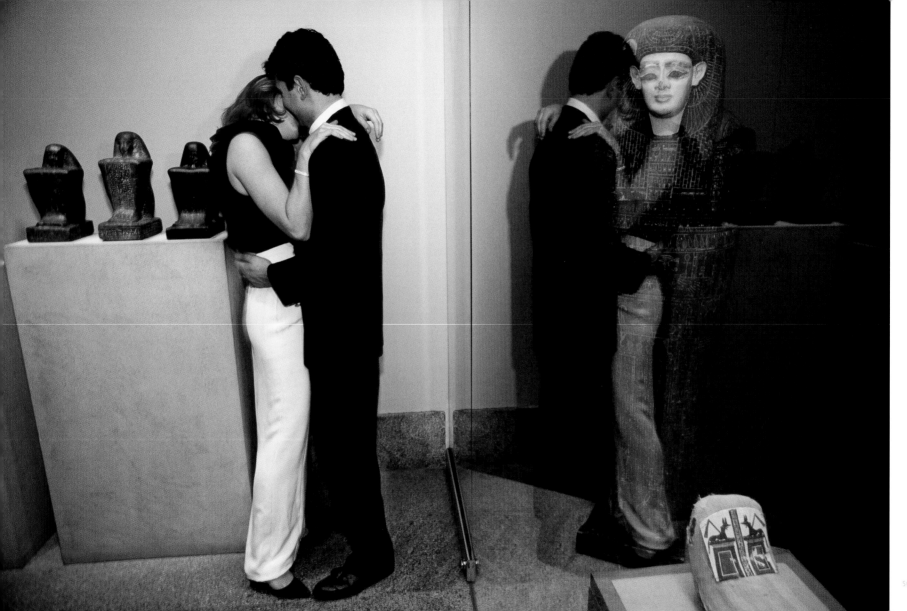

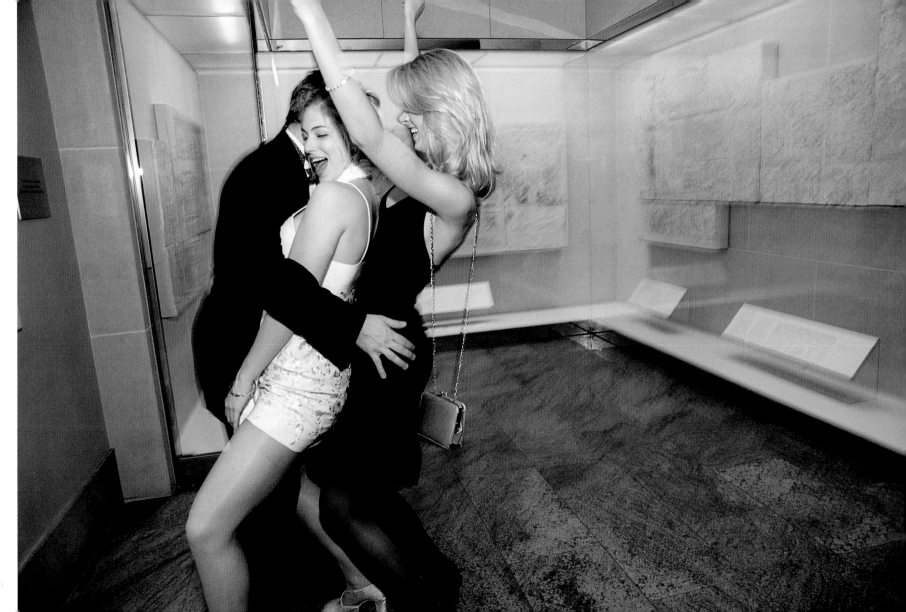

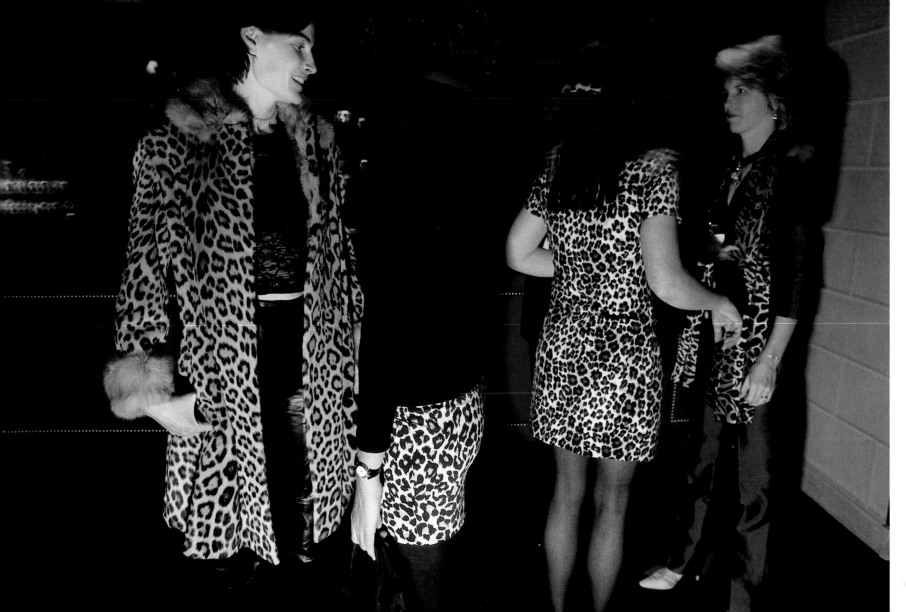

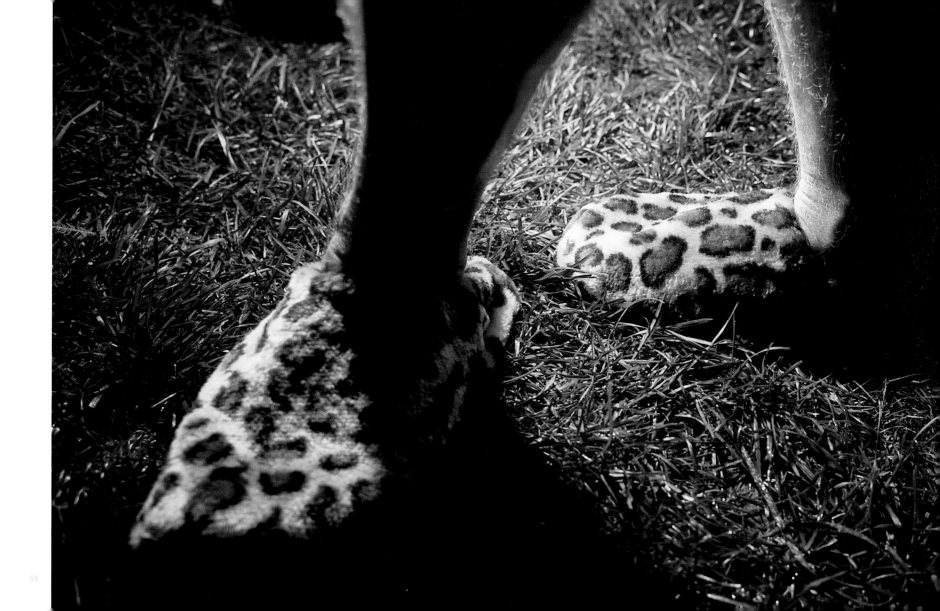

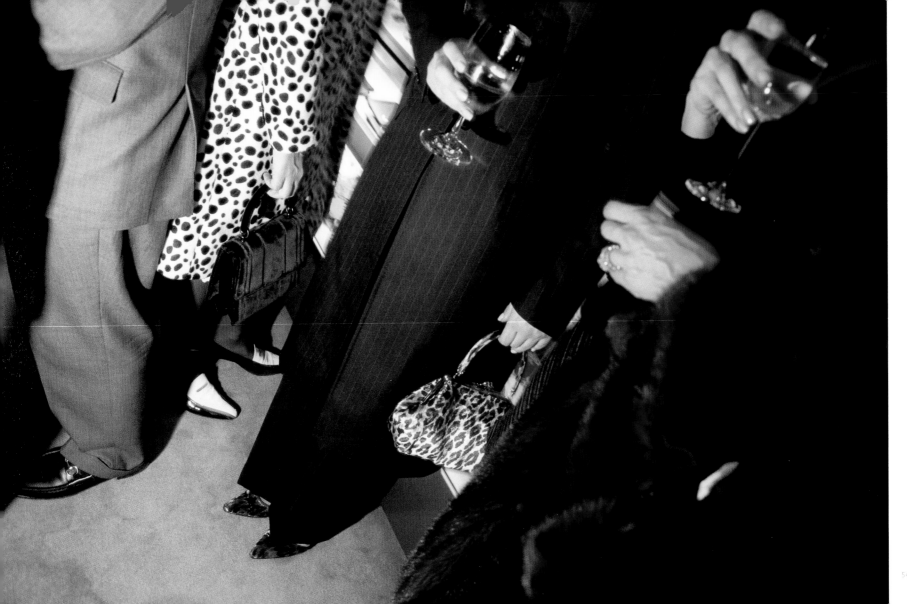

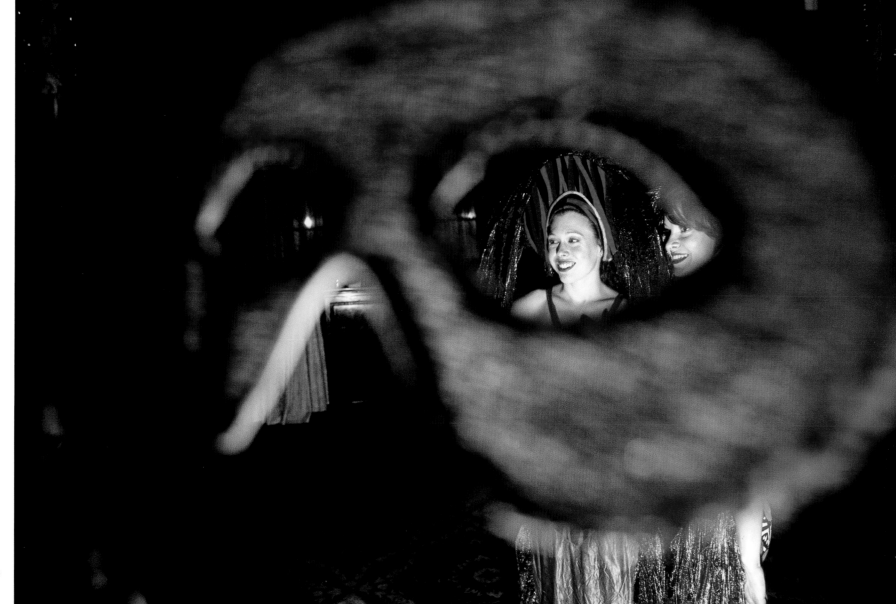

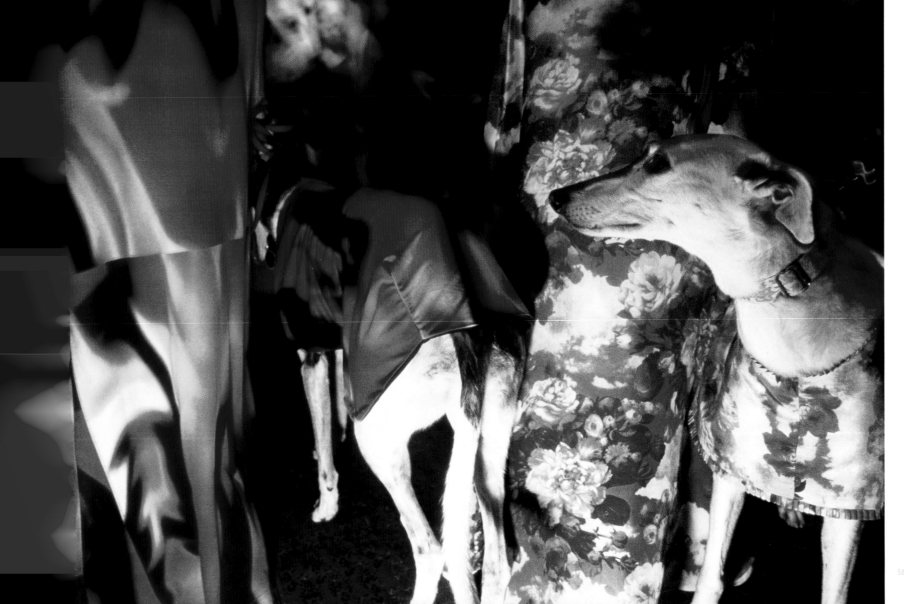

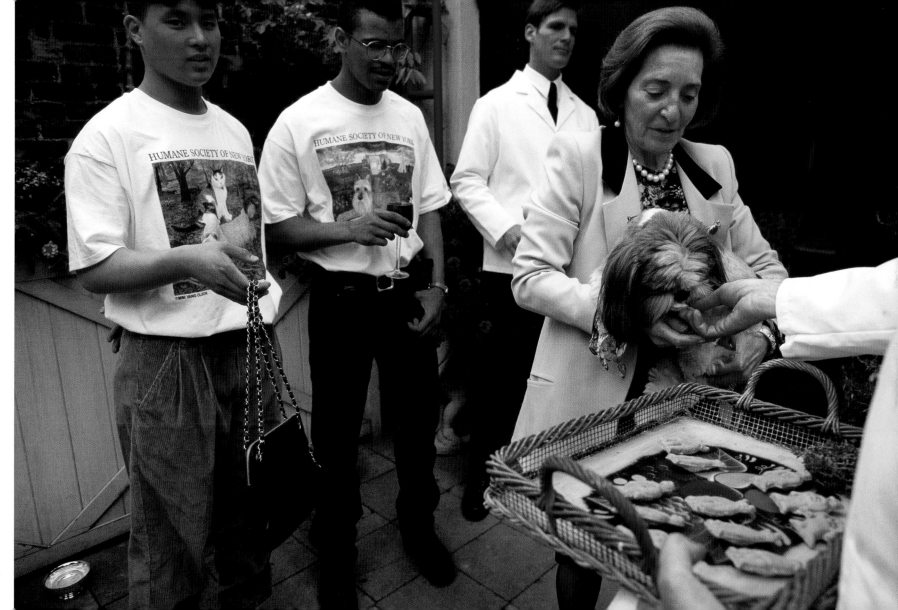

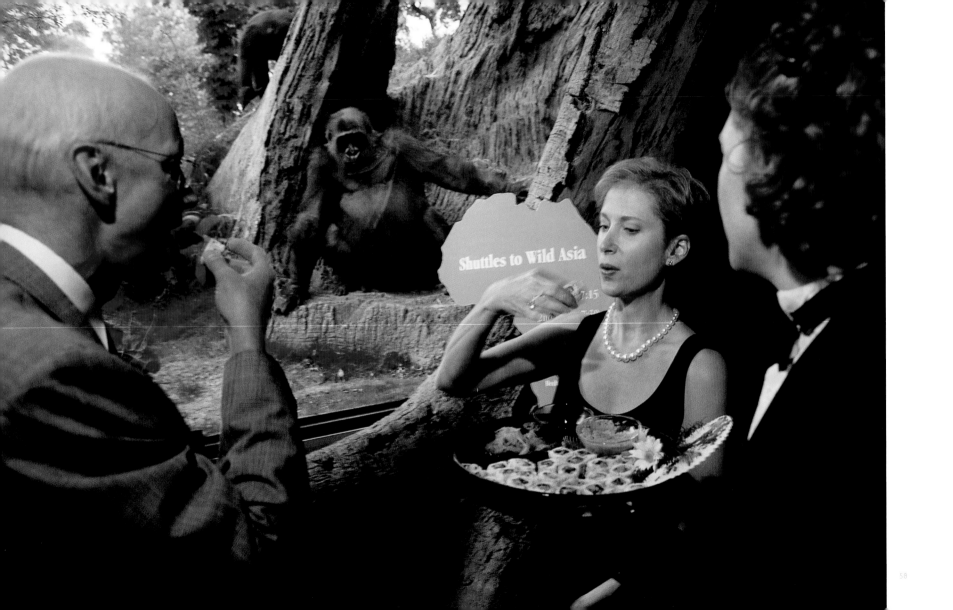

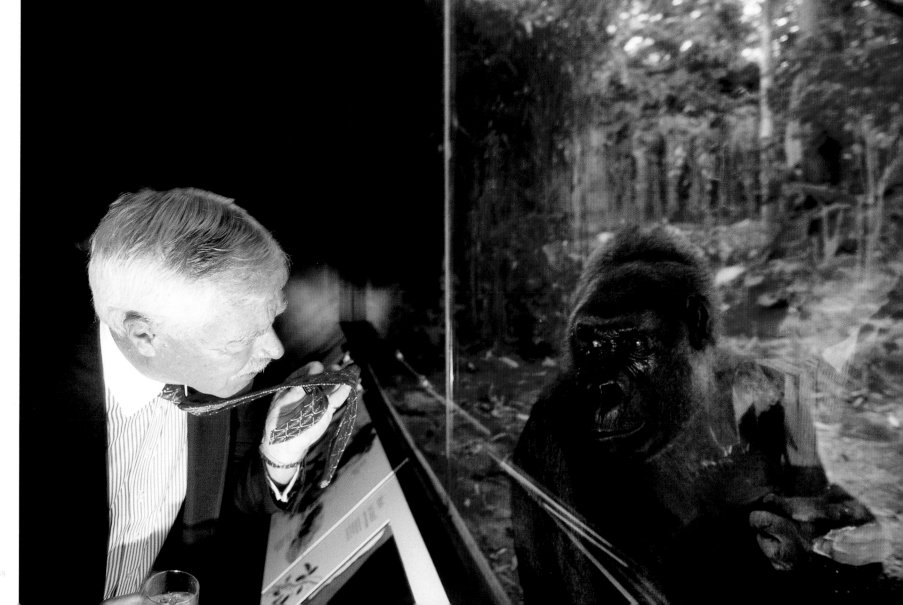

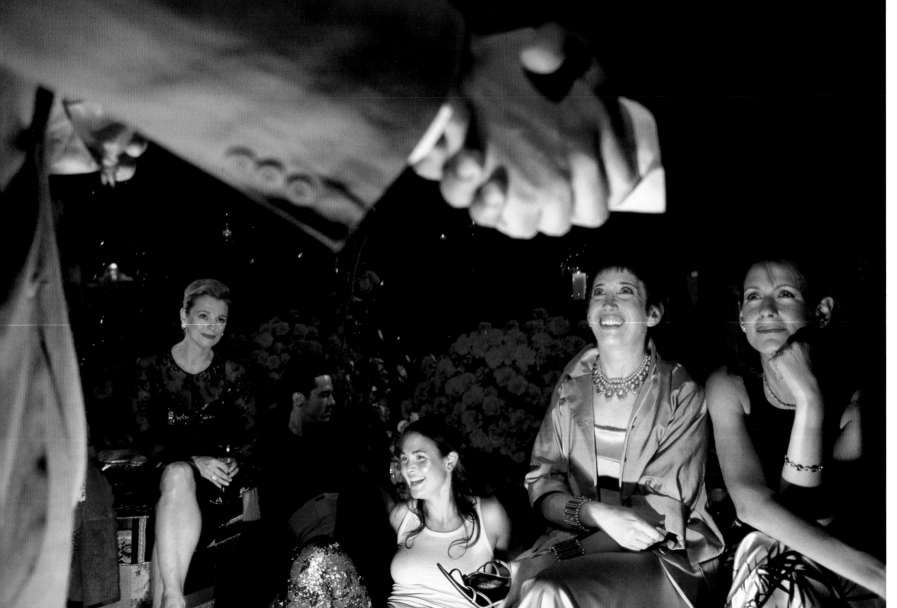

PART TWO: TALK OF THE TOWN

"New York possessed a large wealthy class, which did not quite know how to get the most pleasure from its money, and which had not been trained, as all good citizens of the republic should be trained, to realize that in America every man of means and leisure must do some kind of work, whether in politics, in literature, in science, or in what, for lack of a better word, may be called philanthropy, if he wishes really to enjoy life, and to avoid being despised as a drone in the community."

—Theodore Roosevelt
 from *New York: A Sketch of the City's Social, Political, and Commercial Progress from the First Dutch Settlement to Recent Times*

"I had a guy, I won't mention his name, but he was a businessman from New York, and he showed up last time. I said, 'What kind of art do you do?' He says, 'Well, I fund documentaries.' So I said, 'I'll tell you what, you can get out on the field and practice, but I'm not going to promise you the game.' The first inning I'm making up a lineup, and he comes up and says, 'Where am I?' and I said, 'You're not in this game right now.' The fifth inning rolls around, and finally his daughter came up to me—she was about twenty, with big tits—and she came up throwing her tits at me, saying, 'You're not going to put my father in this game? He's the best player out there!' And this guy was a mediocre player. I said, 'Darling, I don't think so. I got all these people waiting to get into this game.' She said, 'You suck!'"

—Leif Hope, manager of the Artists team at the annual Artists and Writers Softball Game, Bridgehampton, L.I.
 from *The New York Observer*, July 17, 2000

"Philanthropy is almost the only virtue which is sufficiently appreciated by mankind. Nay, it is greatly overrated; and it is our selfishness which overrates it."

—Henry David Thoreau
 from *The Writings of Henry David Thoreau*, Volume 8

"People in our world are swimming in money, but in order to get the city's rich to give a lousy thousand dollars to the poor who are drowning in front of their eyes you have to parade little black kids in front of them and give them party favors. I've read all of Dickens and most of Edith Wharton, but I can't recall coming across anything quite so monstrous. Perhaps I should read more Trollope."

—Felix Rohatyn
 from *Manhattan, Inc.*, April 1986

"The day I got my invitation, you'd have thought I'd won an Oscar."

—Jennifer Love Hewitt, on being invited to the 10th Fire & Ice Ball
 from *InStyle*, March 2001

"Almost everything we own is on the runway. You're going to be absolutely blinded."

—Dawn Moore, spokeswoman for Harry Winston, provider of diamonds to the 9th Fire & Ice Ball
 from the *Los Angeles Times*, December 9, 1998

"There is simply more need for funds, so there are more fund-raisers than ever. We have to think up different ways to make people interested."

—Nan Kempner, legendary New York socialite
 from *The New York Times*, May 12, 1996

"I would not subtract anything from the praise that is due to philanthropy, but merely demand justice for all who by their lives and works are a blessing to mankind. I do not value chiefly a man's uprightness and benevolence, which are, as it were, his stem and leaves....I want the flower and fruit of a man; that some fragrance be wafted over from him to me, and some ripeness flavor our intercourse. His goodness must not be a partial and transitory act, but a constant superfluity, which costs him nothing and of which he is unconscious. This is a charity that hides a multitude of sins."

—Henry David Thoreau
from *The Writings of Henry David Thoreau, Volume 2*

"A Saturday night in the Hamptons means three things: parties, parties, parties."

—Ed Victor, literary agent
 from *The New York Observer*, December 8, 1996

"It was a zoo and I guess they didn't want to put her through it. But I didn't feel she was actually here. I just wanted to see her dance once—but no luck."

—Mica Traynor, fashion designer

"People paid to see her and to all intents and purposes she didn't show up."

—Crickett Richard, debutante

 (Both quotes from *The Daily Mirror*, December 11, 1996; referencing Princess Diana's attendance
 and early exit at a 1996 Costume Institute gala)

"Everybody, from hosts to guests, had an agenda to pursue, whether it was flattering fashion designers, returning hospitality, or promoting the arts, a cause, or a protégé. More important, everyone had come to see and be seen."

—Suzy Menkes, fashion editor, *International Herald Tribune*, on a Costume Institute gala
 from *The Independent*, December 8, 1996

"If you're asked for money every day, as some people are, you're more likely to give if there's an event to go to. And it can not be just any event. It has to be a signature event that reflects the invitees' level of prestige or style or kookiness. Otherwise, they stay home."

—Carleen Cappelletti, sr. vice-president, Merv Griffin Productions
 from *Los Angeles Magazine*, February 1, 2002

"I was in billionaire heaven. Ronald Perelman, Mr. Giorgio Armani, and Mr. Rupert Murdoch. It was so exciting I could hardly handle it. I was thinking, 'God, you could cure cancer with these three gentlemen.' That evening took us to another hemisphere. E! channel started doing one-hour specials. We set a standard so high the problem became, 'What are we going to do next?'"

—Lilly Tartikoff, organizer, on the 4th Fire & Ice Ball
 from *Los Angeles Magazine*, February 1, 2002

"Celebrities are a brand, and a brand must stand for something. I mean, some celebrities will go to the opening of a wound."

—Howard Bragman, Hollywood publicist
 from *Los Angeles Magazine*, February 1, 2002

"You buy a table, and two weeks before the event you get a phone call from an assistant. 'Would you please fax the names of your guests?' If your guests are not fabulously recognizable, your table gets moved toward the kitchen."

—anonymous L.A. socialite
from *Los Angeles Magazine*, February 1, 2002

"For children's diseases and rehabs you get the best celebrities."

—anonymous L.A. journalist
from *Los Angeles Magazine*, February 1, 2002

"The perennial fashion spectacle was in full bloom earlier this month at the Frederick Law Olmsted Awards Luncheon, given by the Women's Committee of the Central Park Conservancy. Held in the Conservatory Garden in Central Park, at Fifth Avenue and 104th Street, the event raised $1.9 million for the restoration and upkeep of the park. Most of the one thousand women who attended dressed in pastel suits or coats and matching dresses. Of those, 458 wore hats, a few decorated with fresh flowers. (One young woman wore a baseball cap.) Of 114 tables, only three were hatless. The star colors were shades of pink, rose, and mauve. Executive women and corporate wives still cling to the romantic silhouette of the post–World War II Paris suits with small, rounded shoulders and an hourglass waist....The impeccably tailored guests in their Ascot-style hats offered a rare view of a nearly vanished romantic mode of dress. They carry on a vision of femininity from an earlier time, when appropriateness set the guidelines for clothing. The scene is one of the last grand displays of fashion, once commonplace at the races at Ascot, Paris, and Saratoga."

from *The New York Times*, "Sunday Styles," May 16, 1999

"Designers go to the dogs.
If you can stand the idea of dogs dressed up in couture clothing, go along to tomorrow's Animal Rescue Fund gala in East Hampton. Designers, including Diane von Furstenberg, Donna Karan, Ralph Lauren, and Vera Wang, have all pitched in to dress the pooches, and ARF does do tremendous work."

from the *New York Post*, July 23, 1999

"The dynamics of it is that you say to yourself, okay, we've got to raise x money. Let's just let the ticket price rise to a thousand-dollar fee. Okay, if you're going to do that, my gosh, we have to give them a really good dinner, we have to have some really good music, we have to have a spectacular person for the entertainment, we have to have magnificent flowers, we have to give each woman a present to take home to remember that she came to his wonderful thing. That's where I think it gets out of line. I mean, wait a minute, isn't this to take in money and not give out money? You know, let's not have party favors. I think that's defeating the purpose."

—Elizabeth Rohatyn
from *Manhattan, Inc.*, April 1986

"If you go to a board meeting, 80 percent of the discussion is about fund-raising. Programs—What are we supposed to be doing? How are we doing?—get about 20 percent of the time. Board and staff members alike sit around saying 'Who can we honor? Who will look right for dinner?' It's turned into a racket. They'll put almost anybody up there, no matter how dissonant the choice seems, to get the money. They wheel out the victims of human-rights abuses and give them a couple of minutes, but the main event is to rub shoulders with the celebrity. It's a real sign of the degradation of our civic culture."

—anonymous media executive, involved with several nonprofit human-rights organizations
from *The New York Times Magazine*, November 19, 1995

PART THREE: SAVOIR-FAIRE

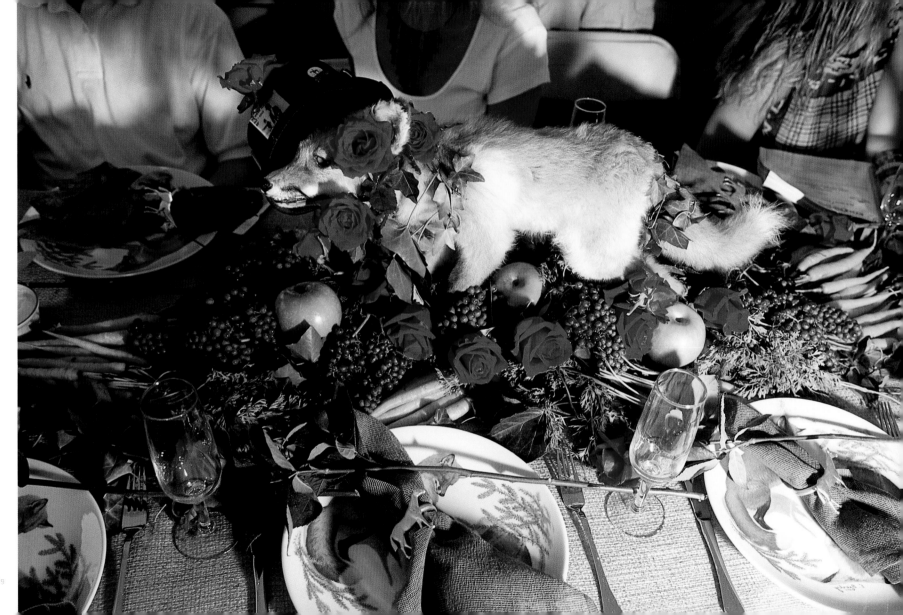

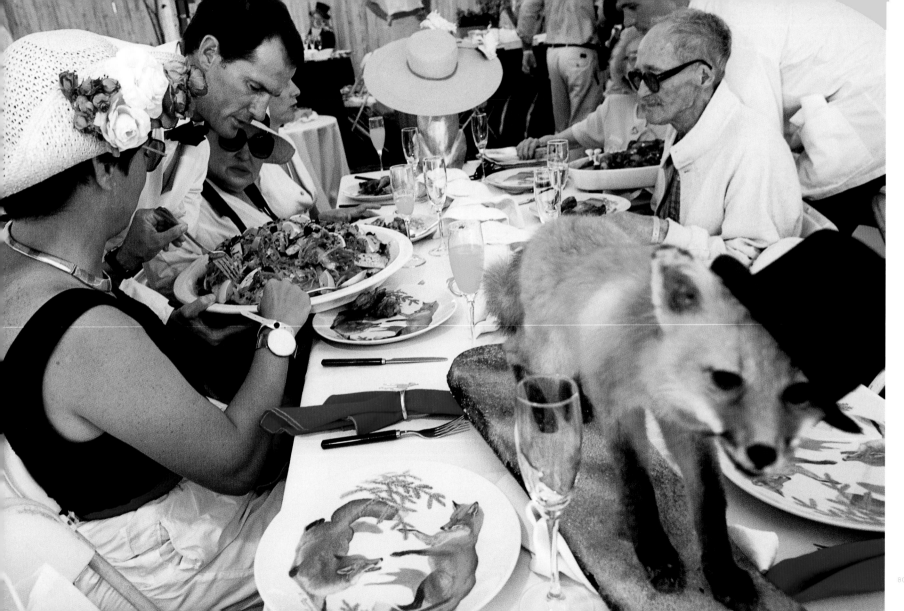

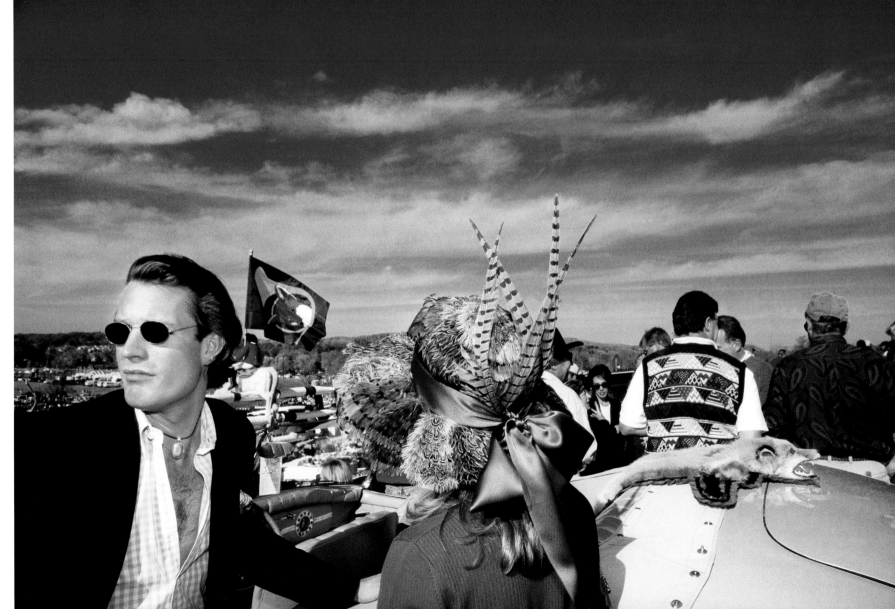

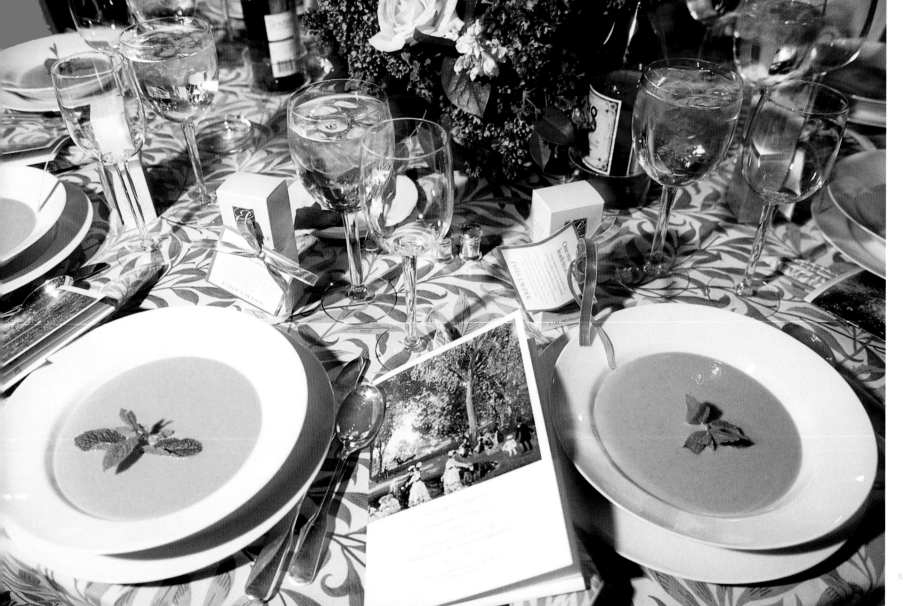

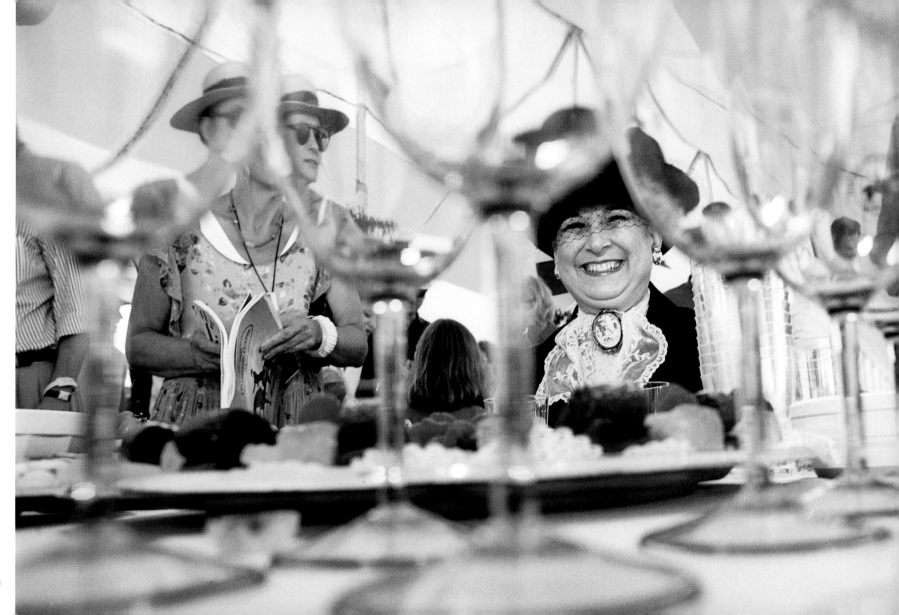

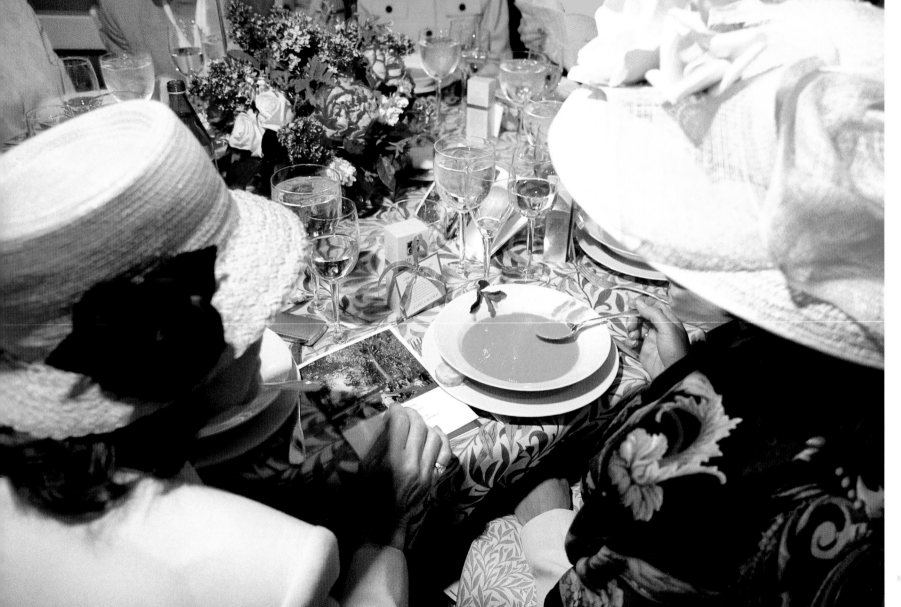

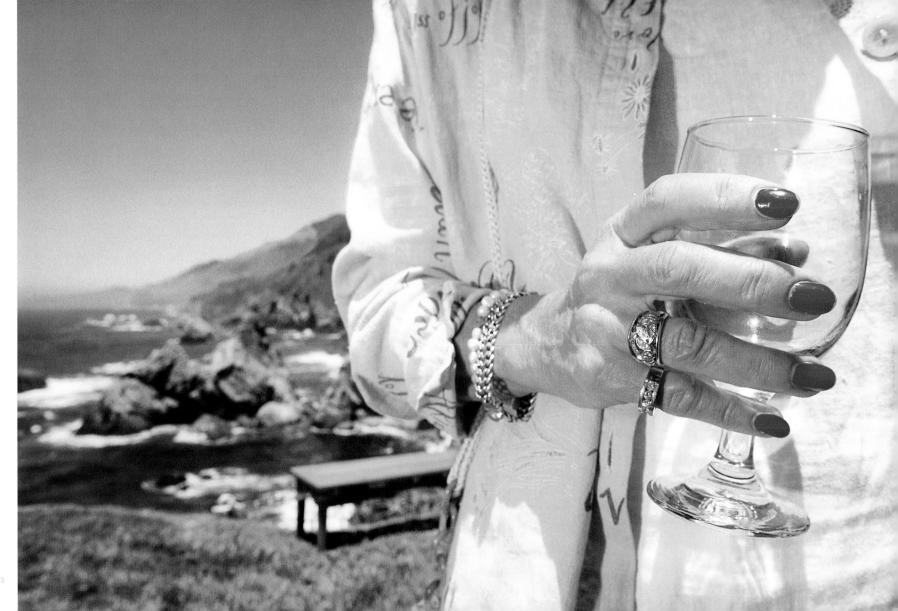

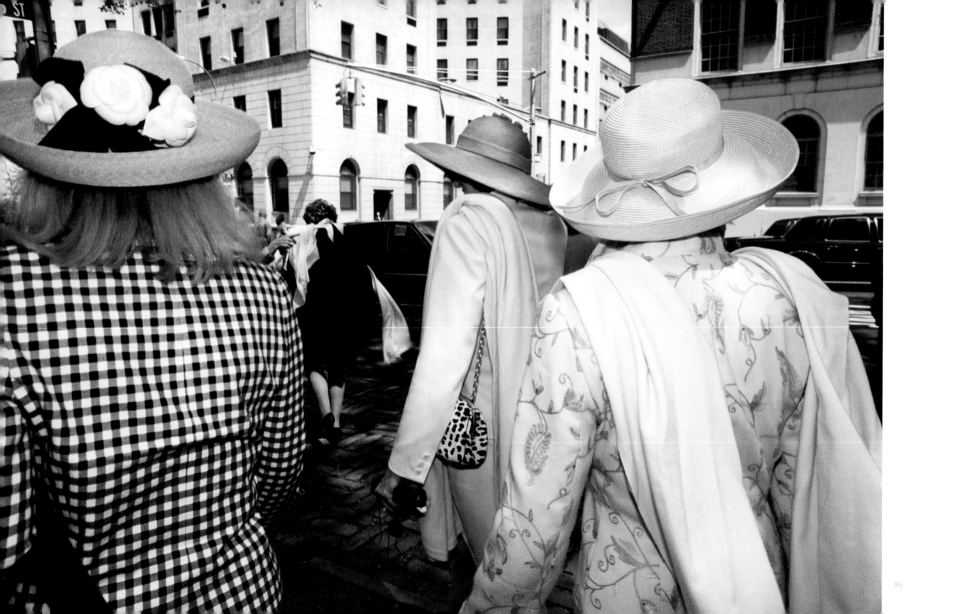

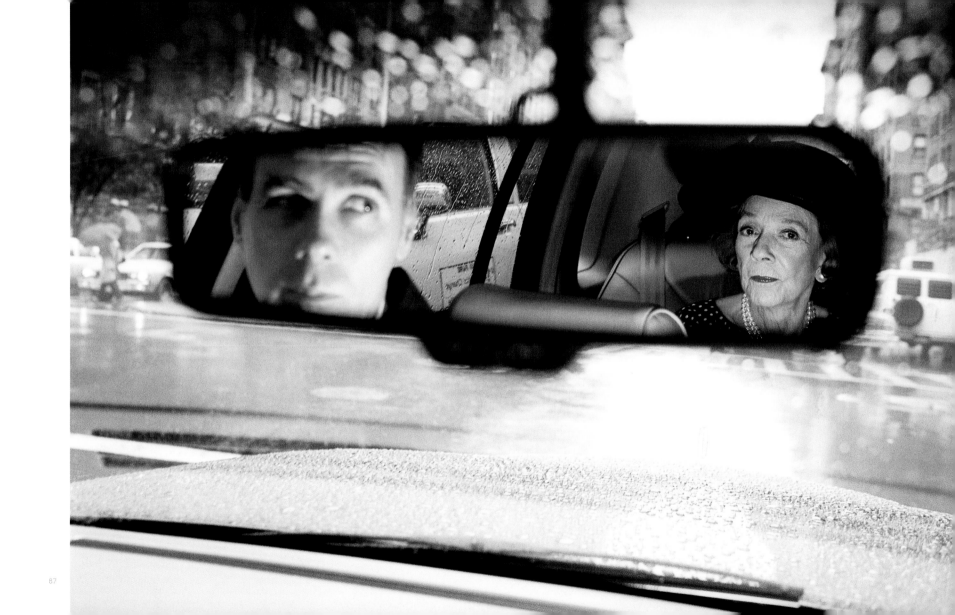

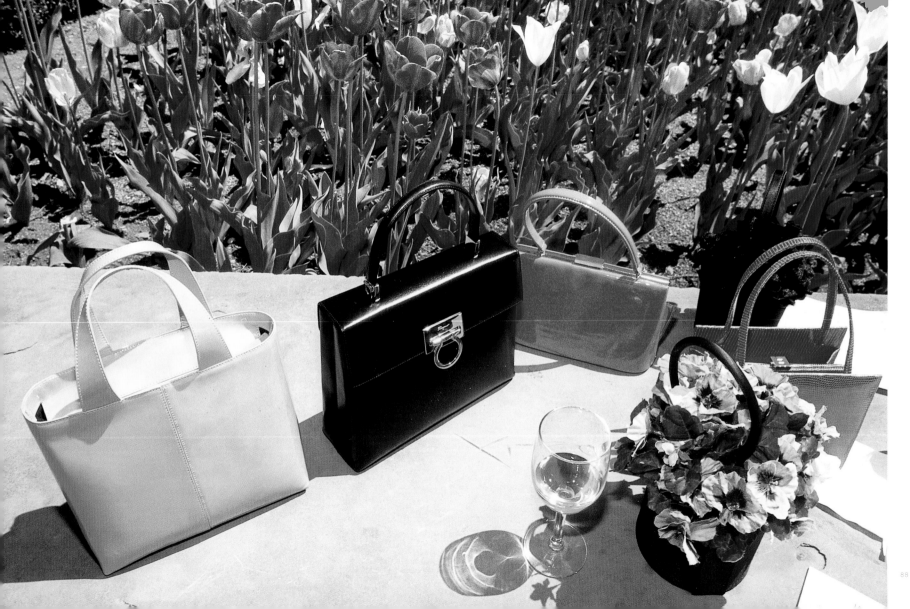

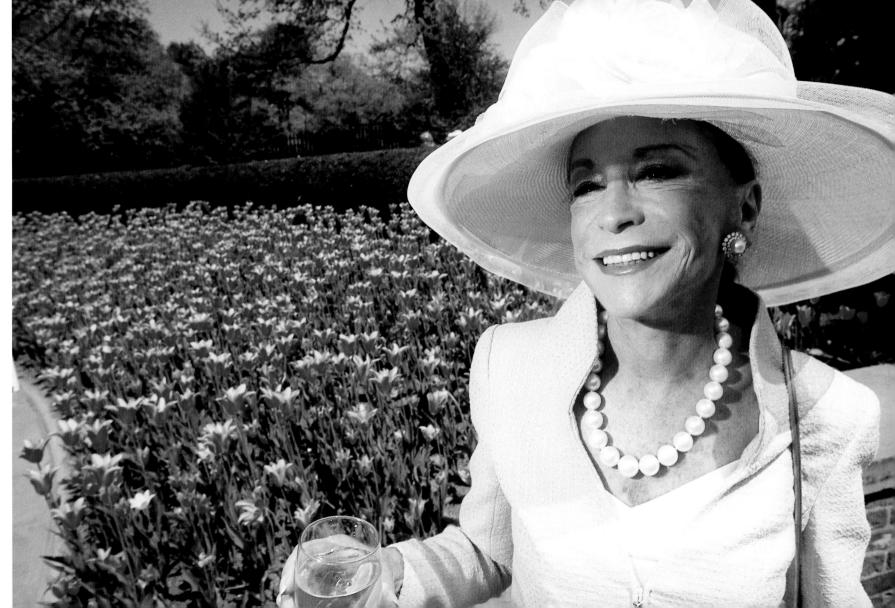

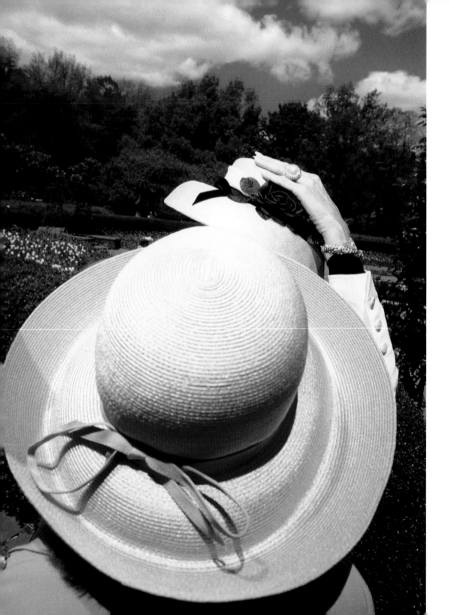

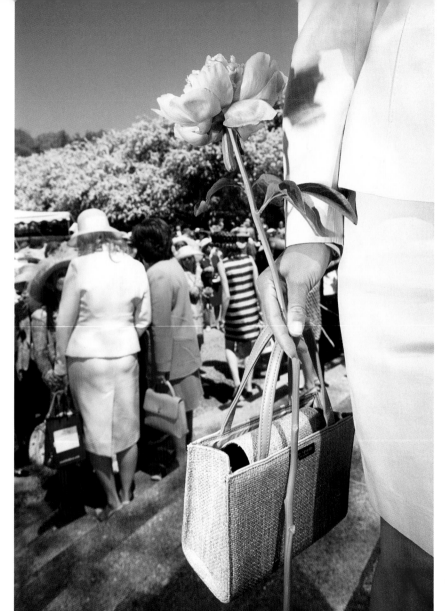

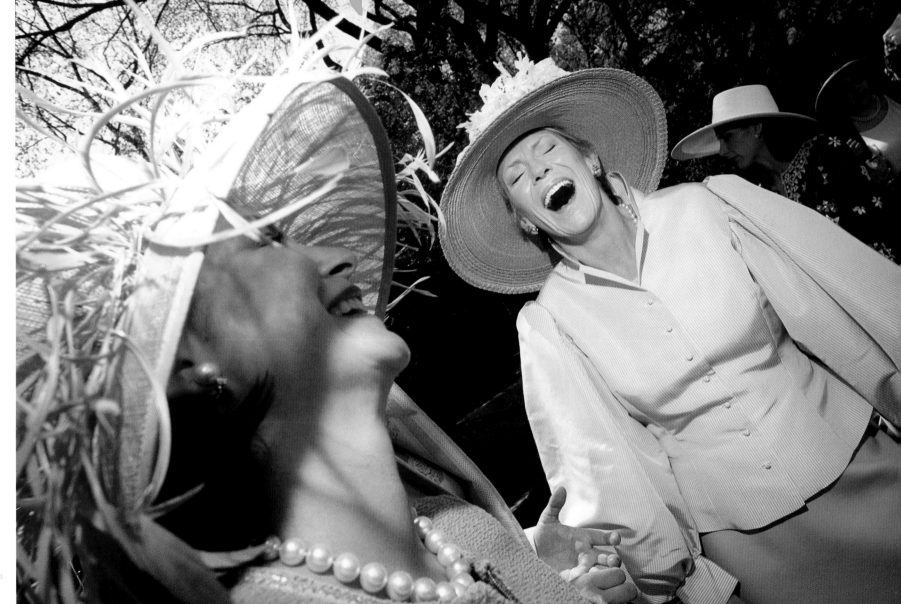

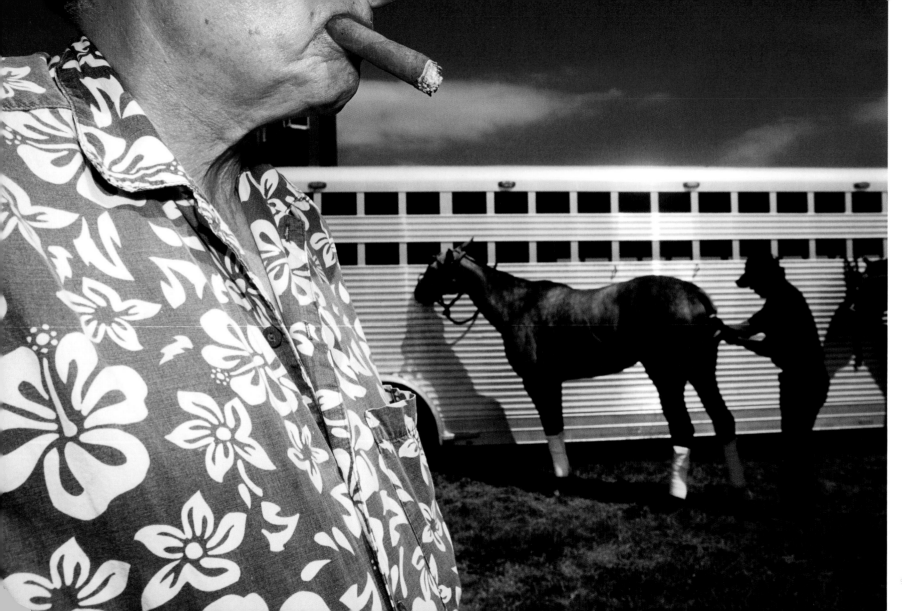

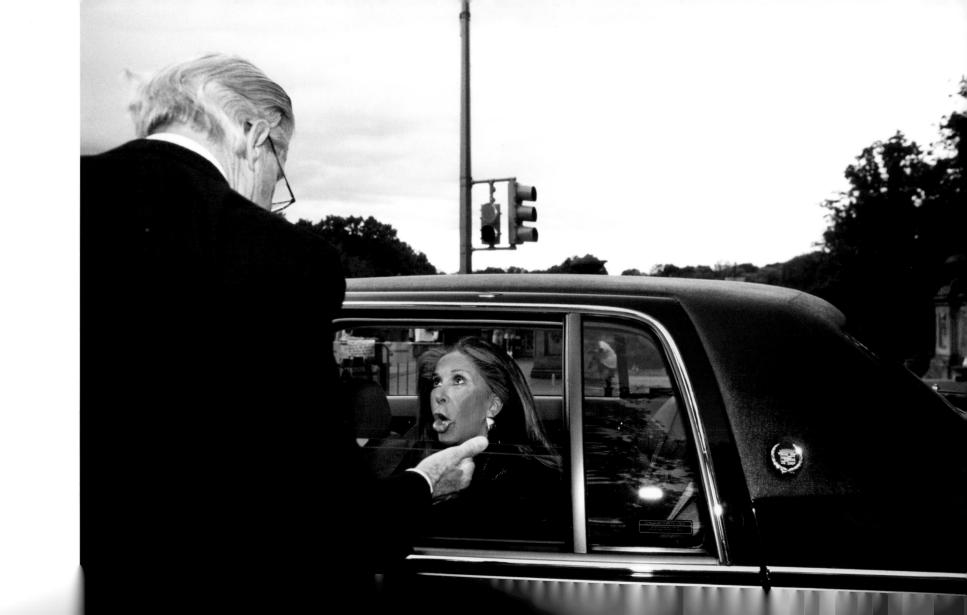

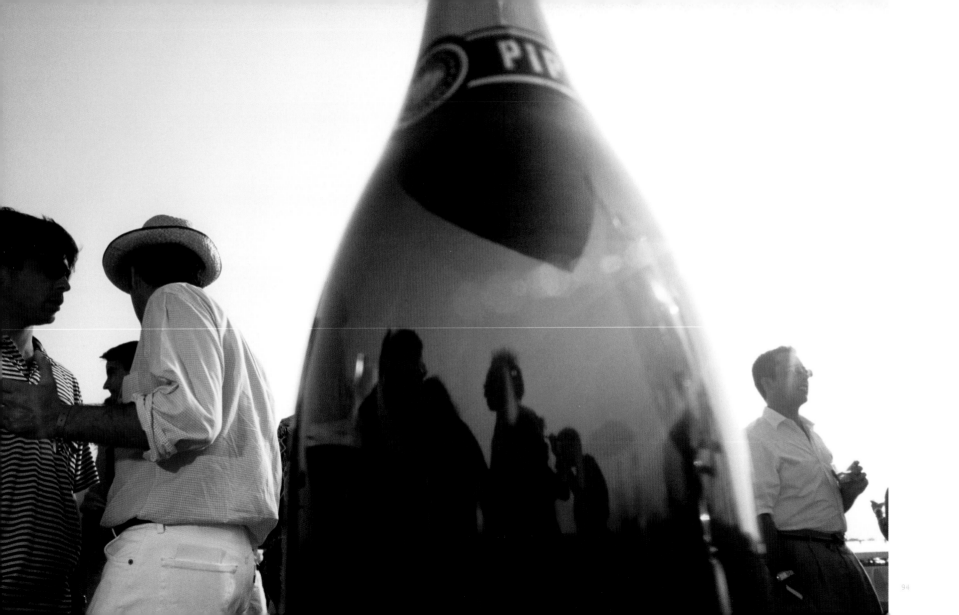

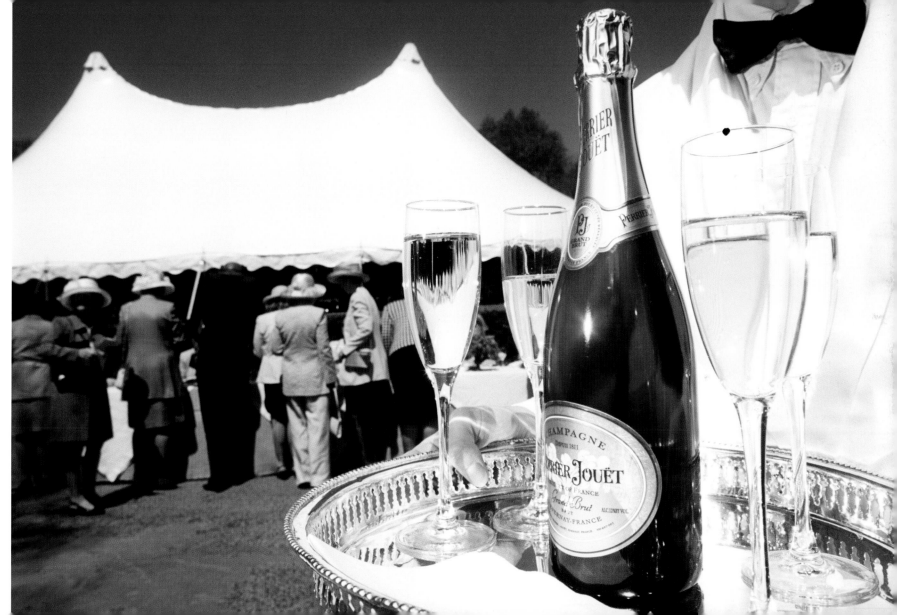

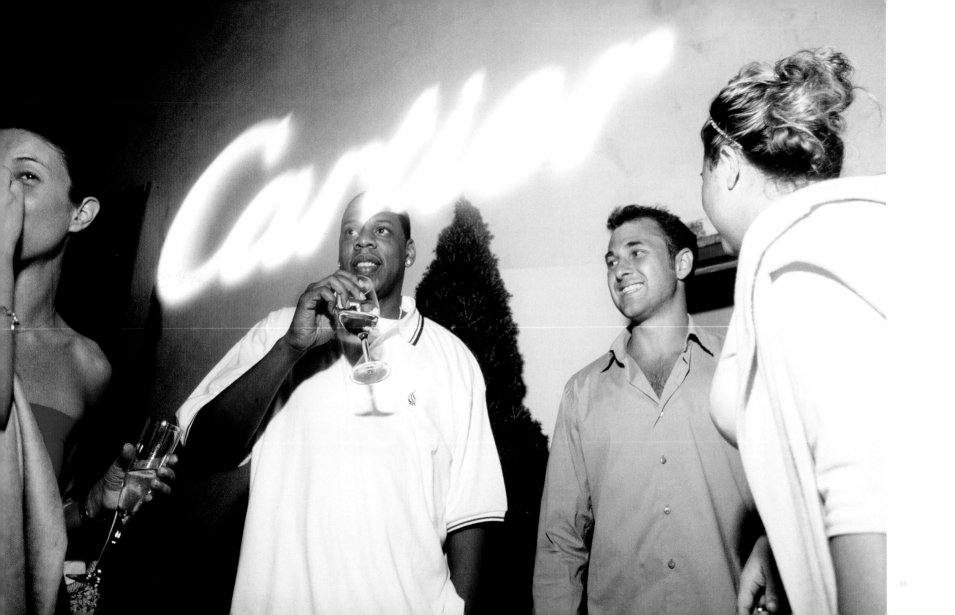

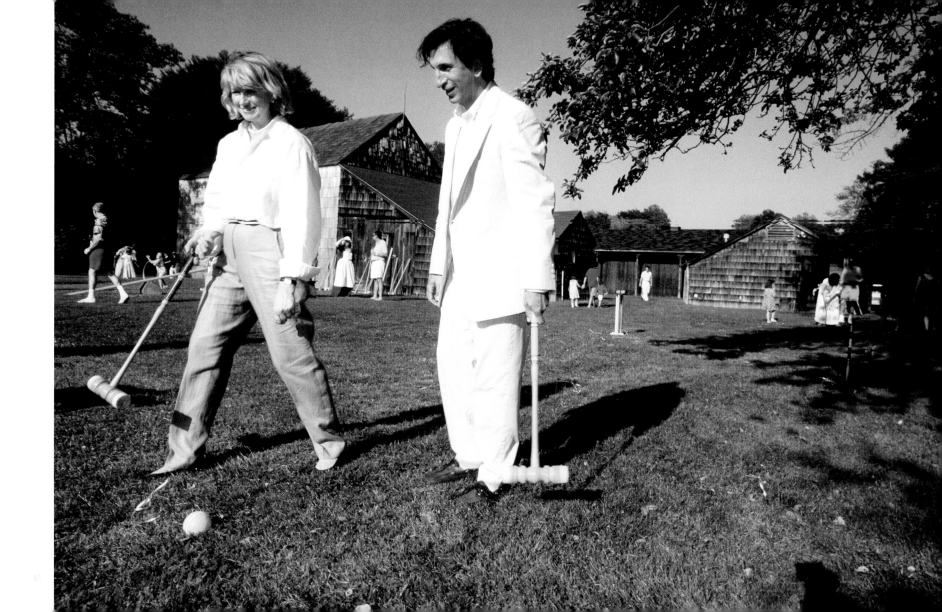

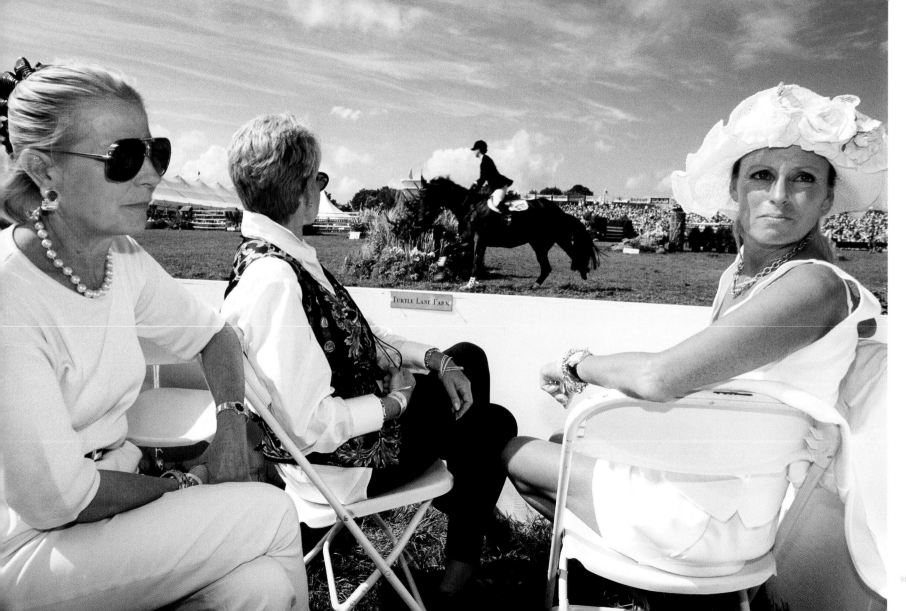

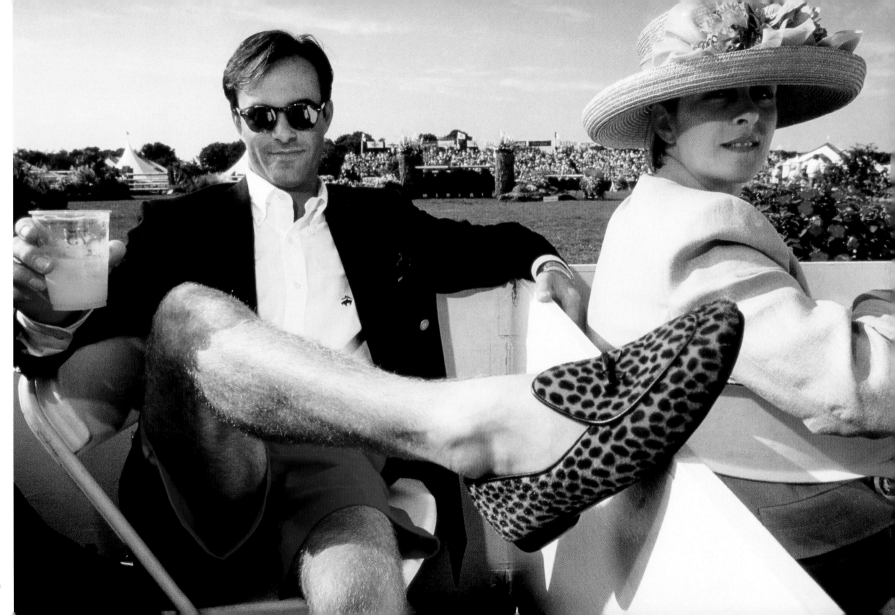

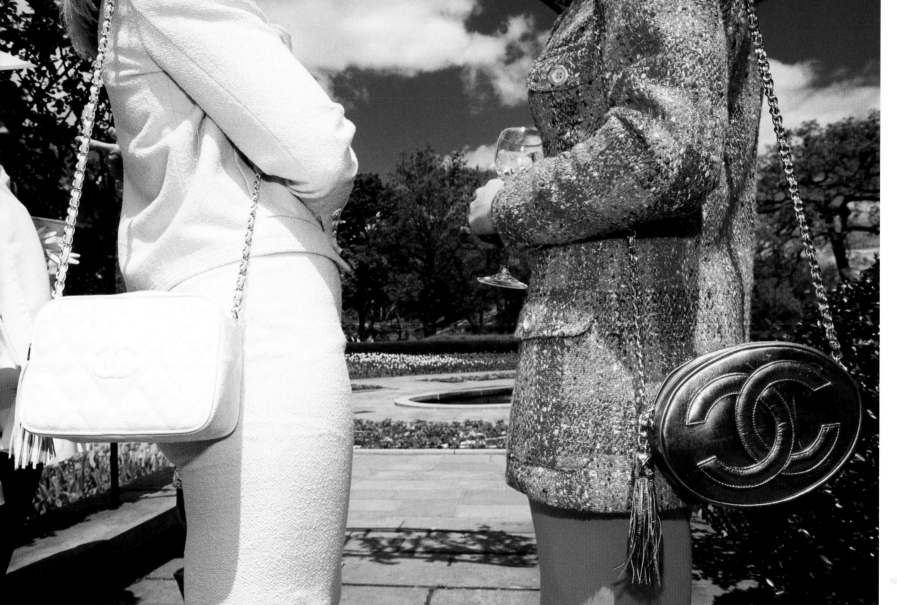

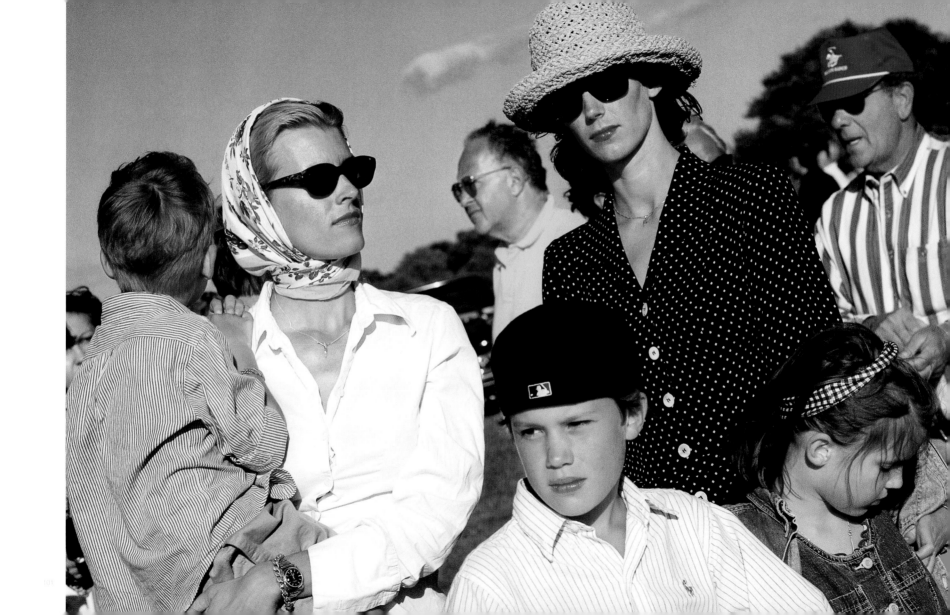

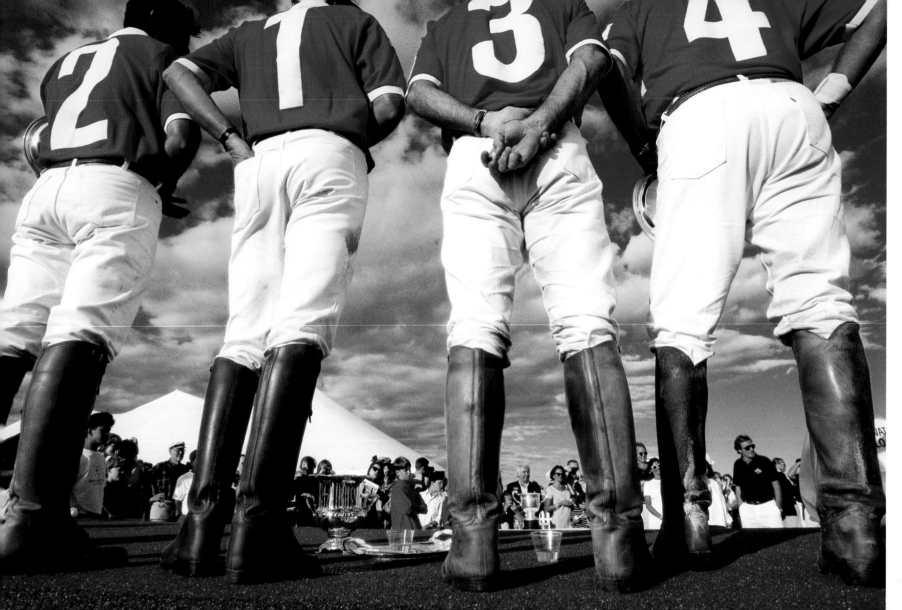

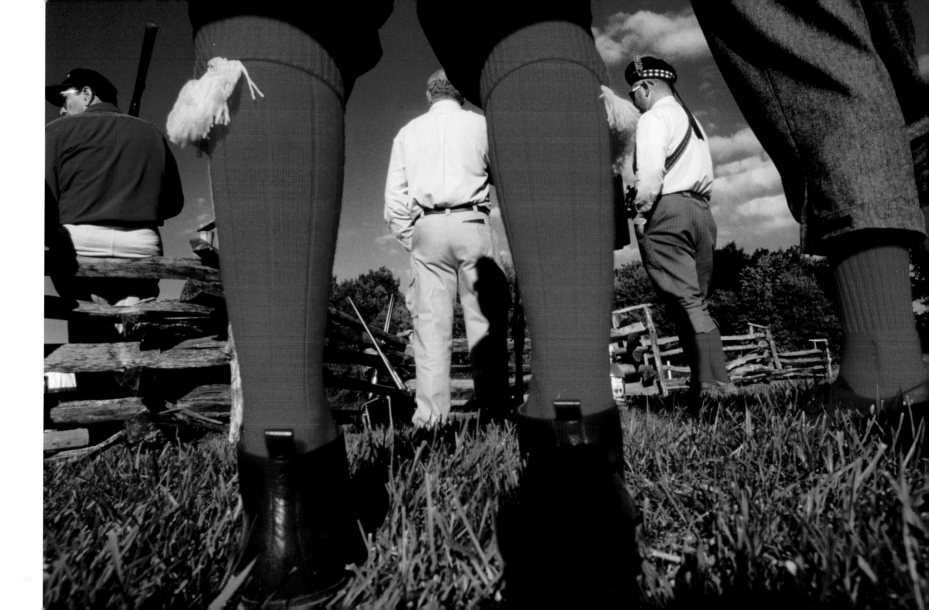

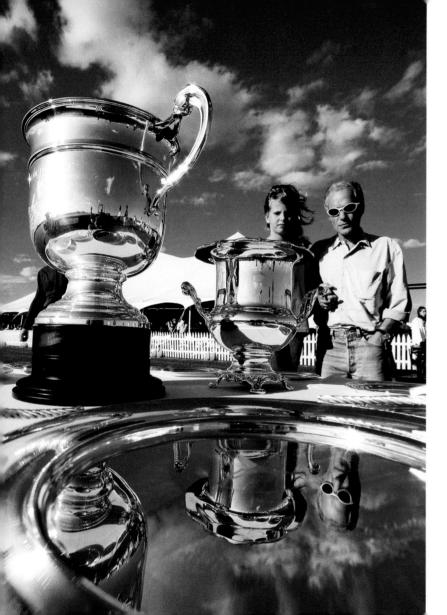
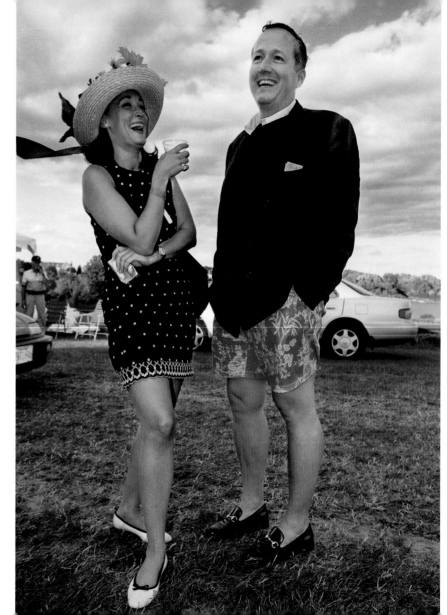

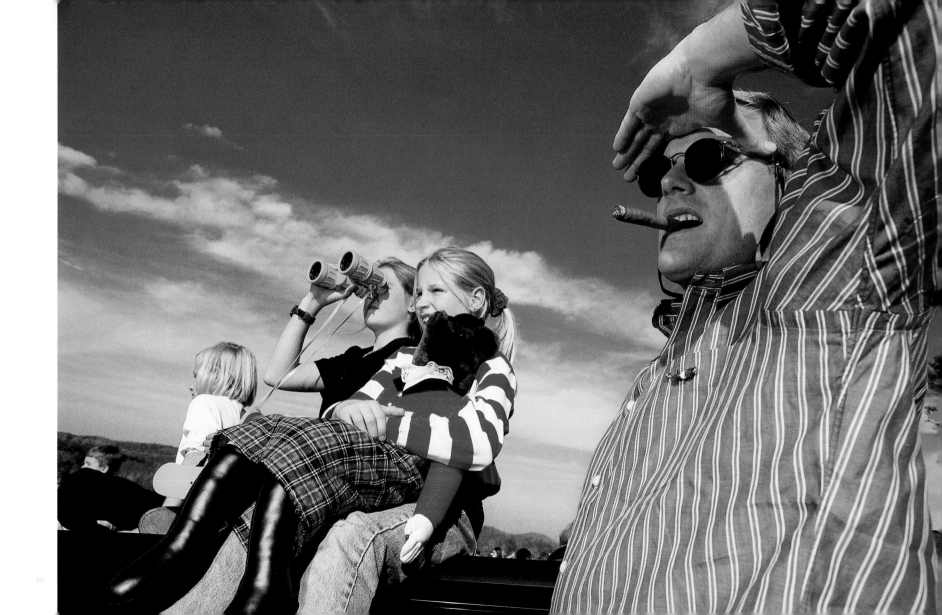

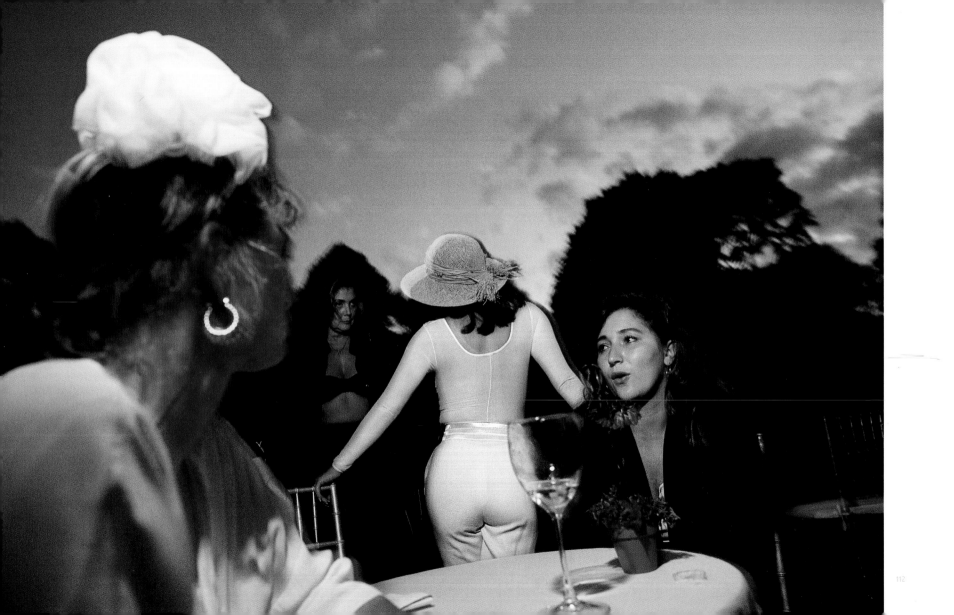

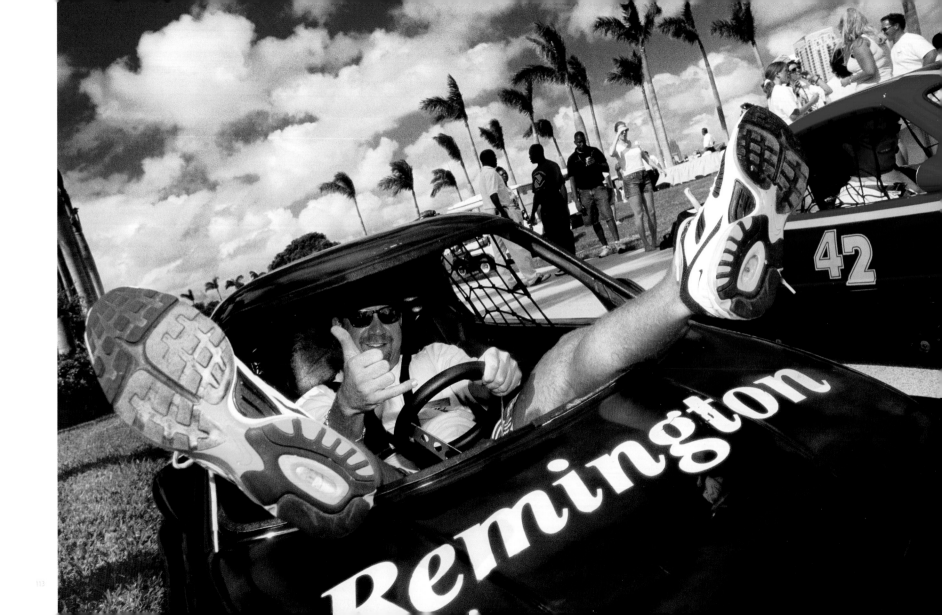

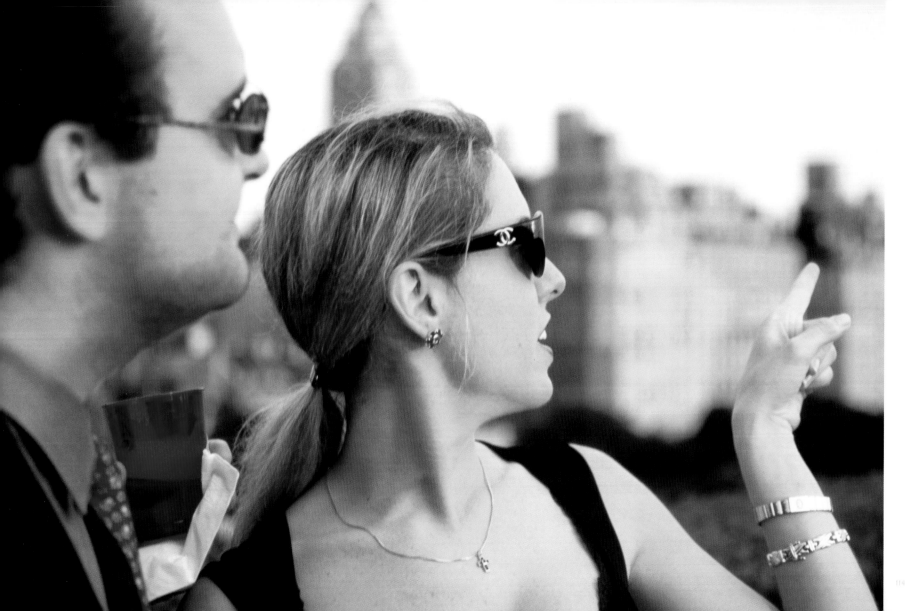

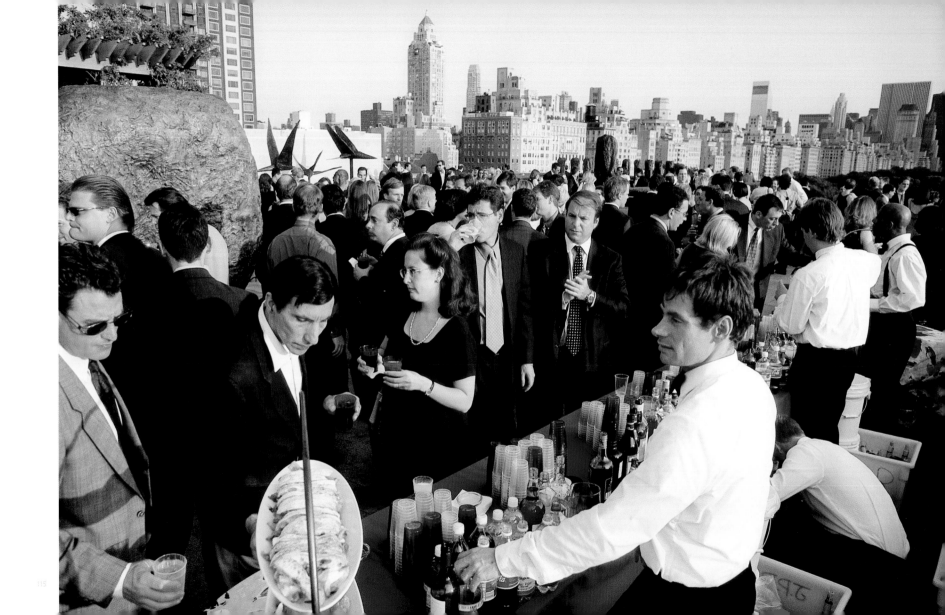

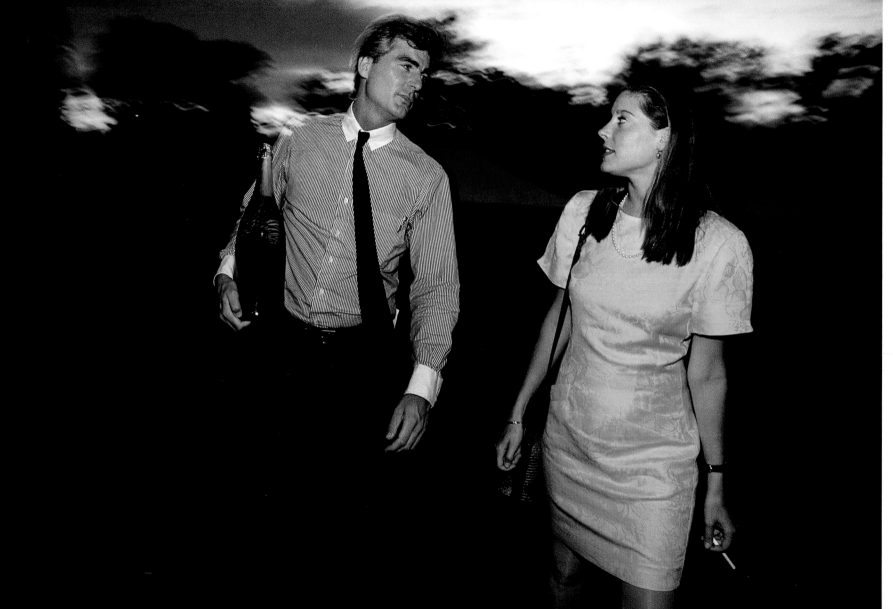

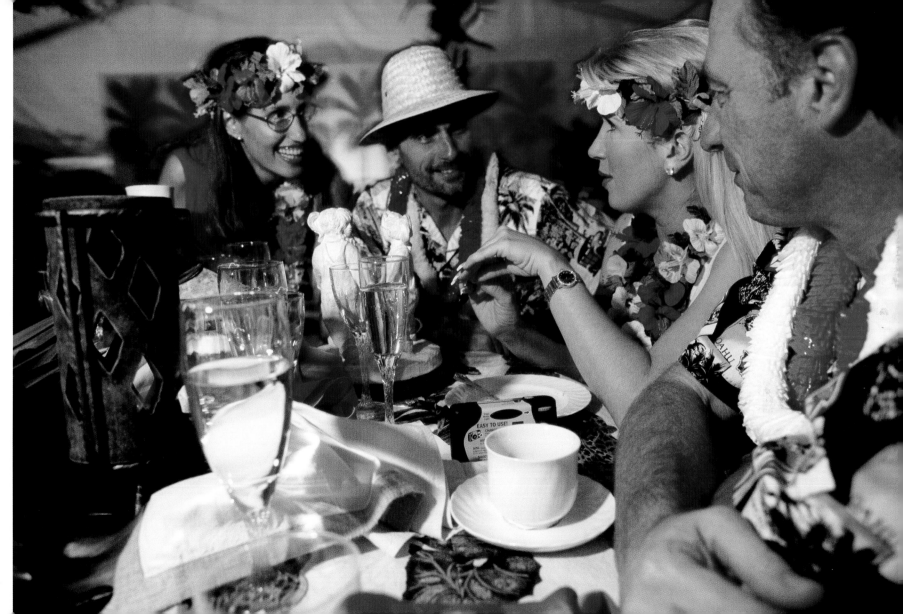

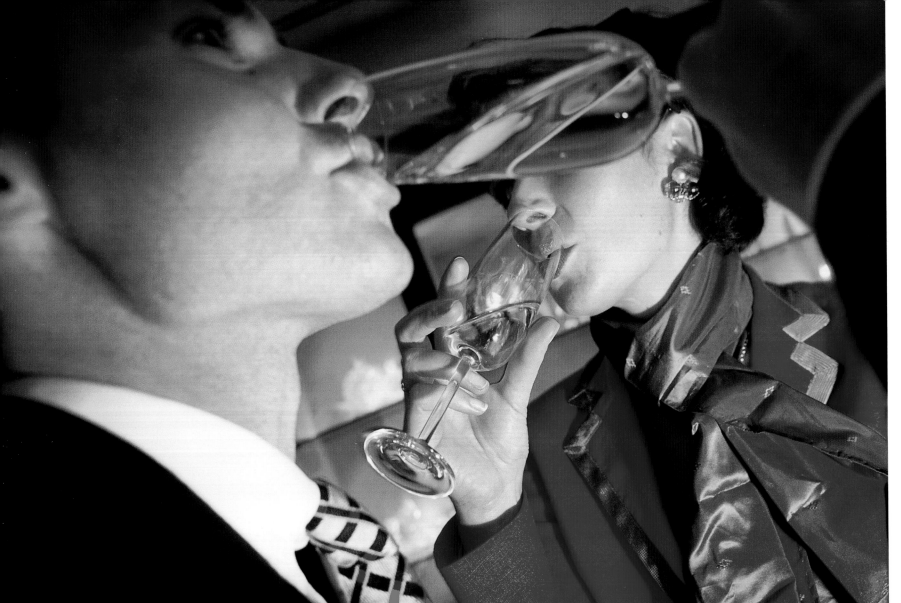

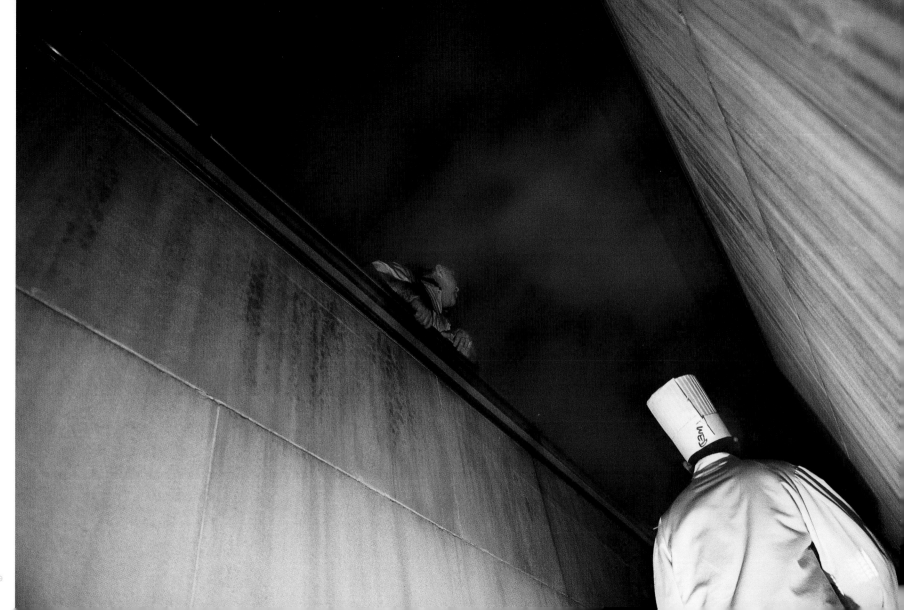

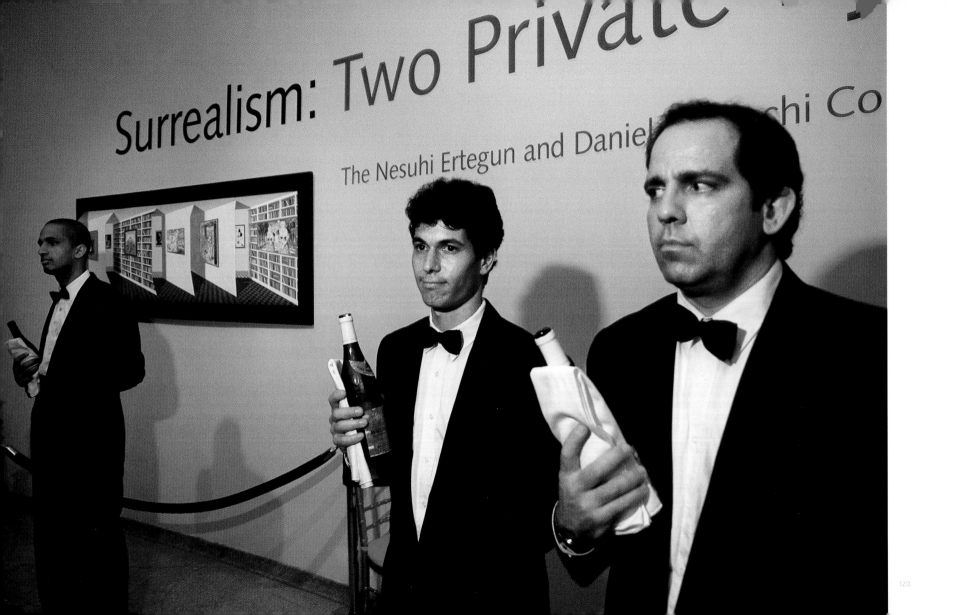

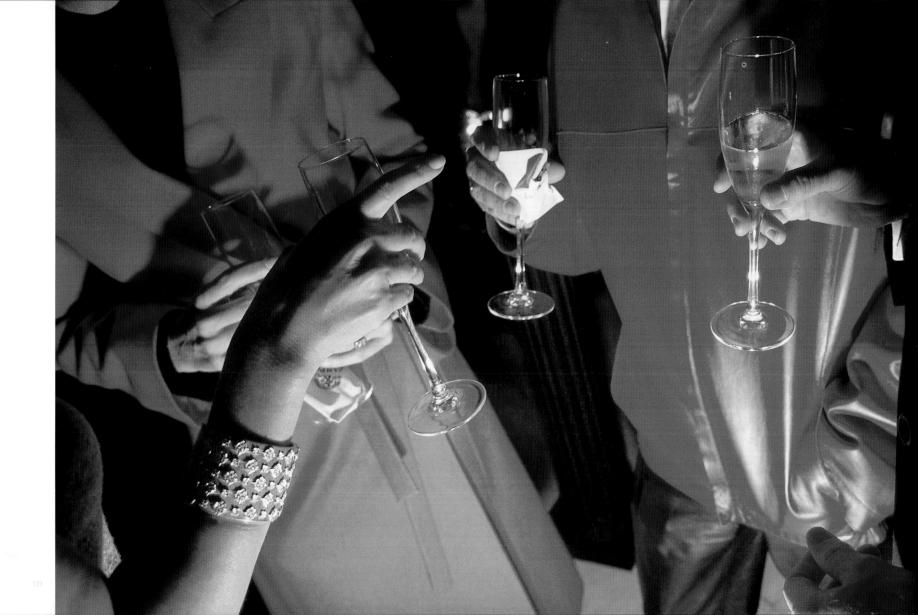

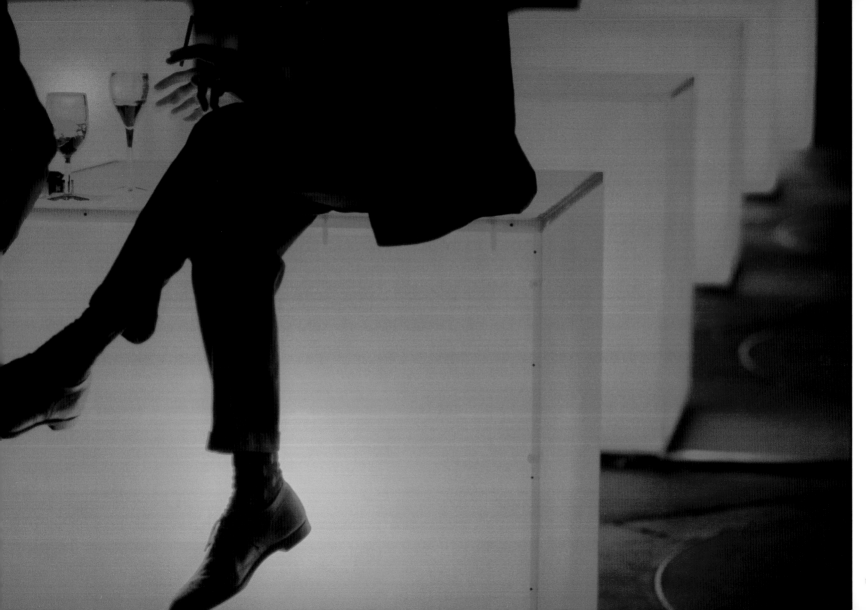

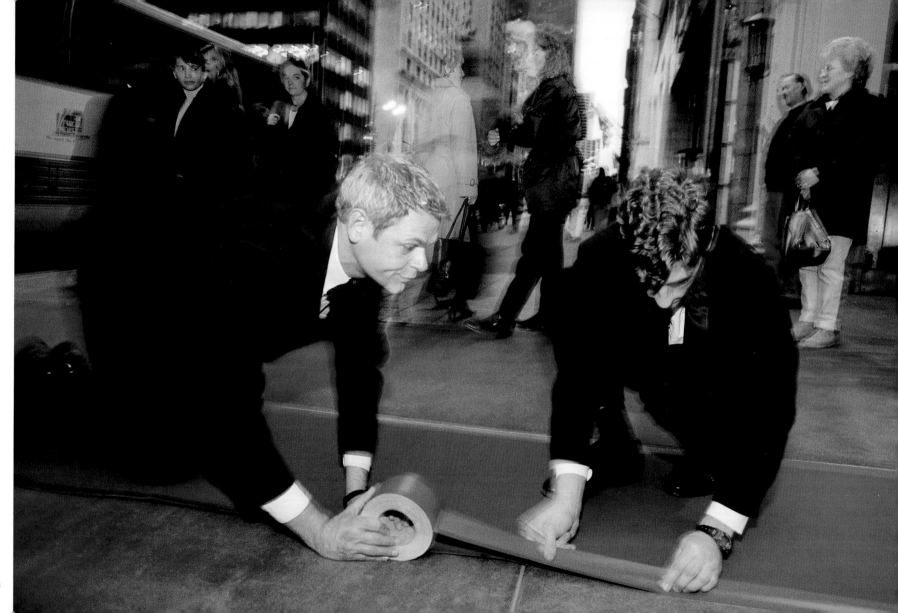

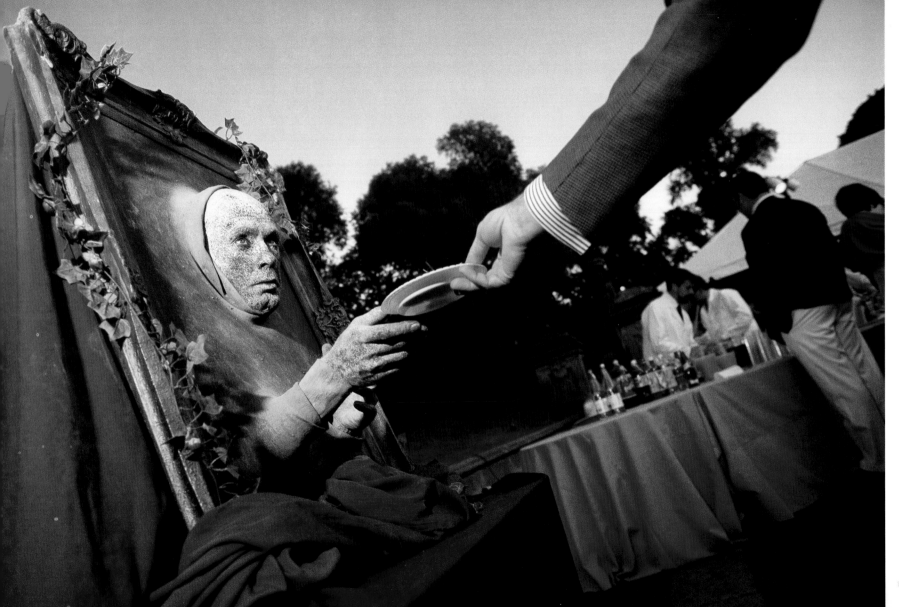

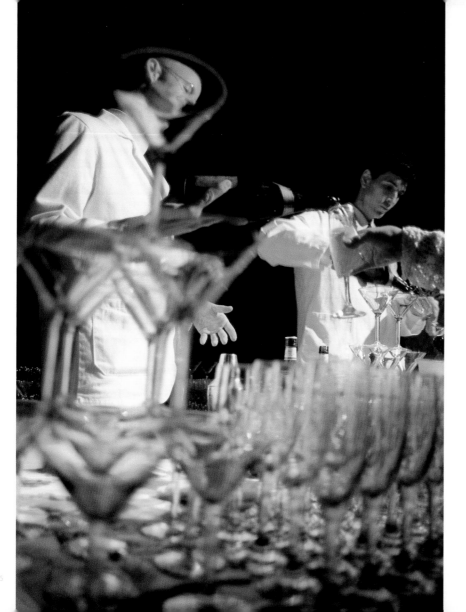

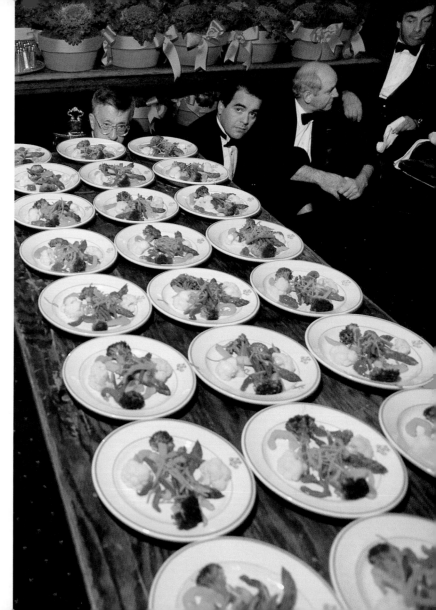

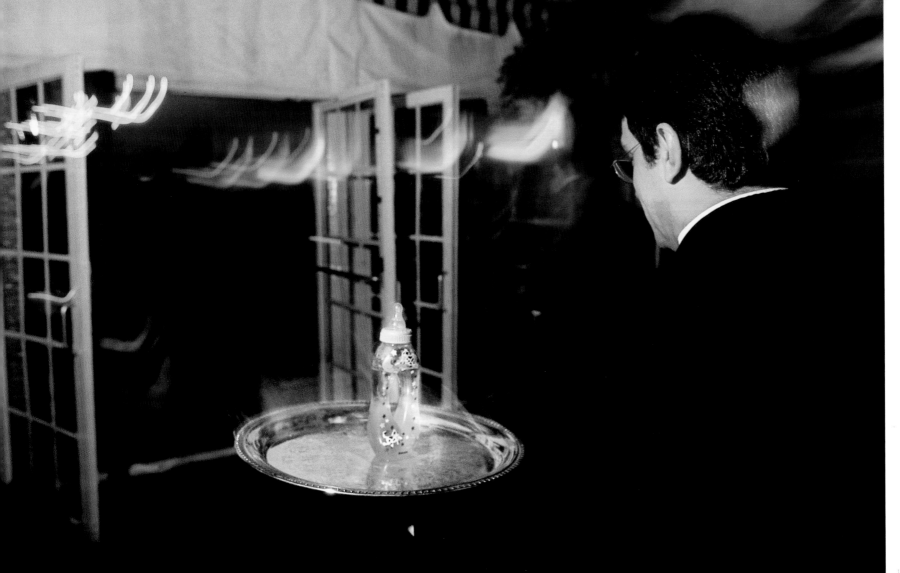

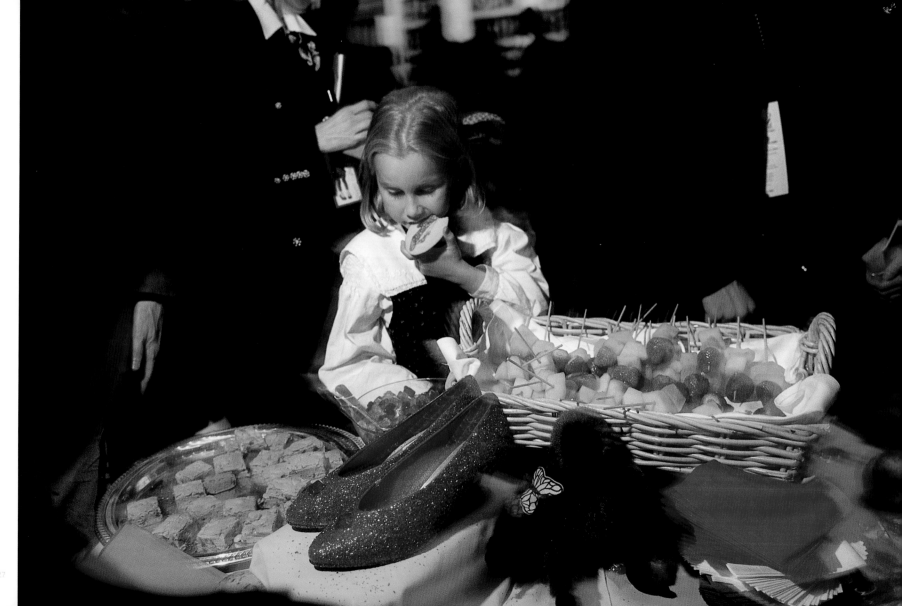

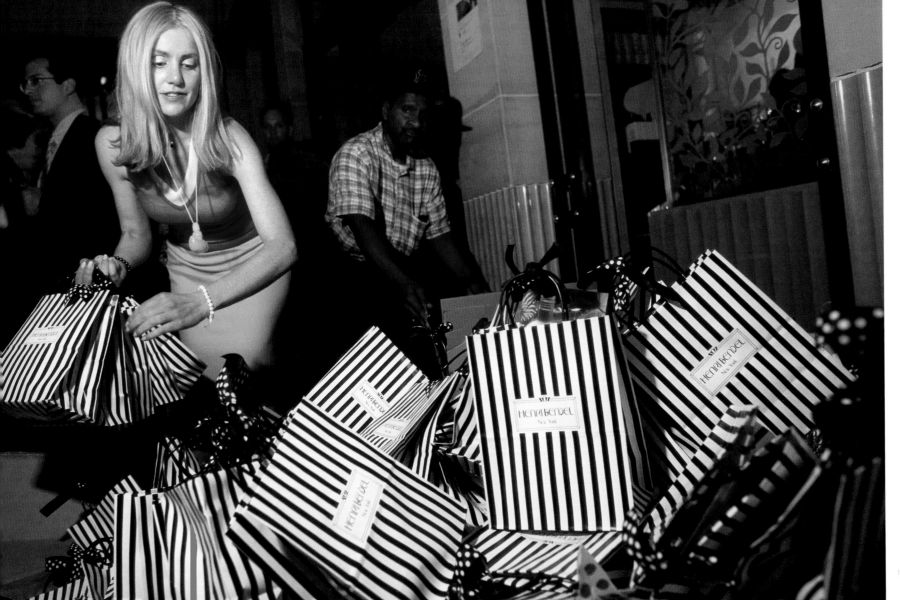

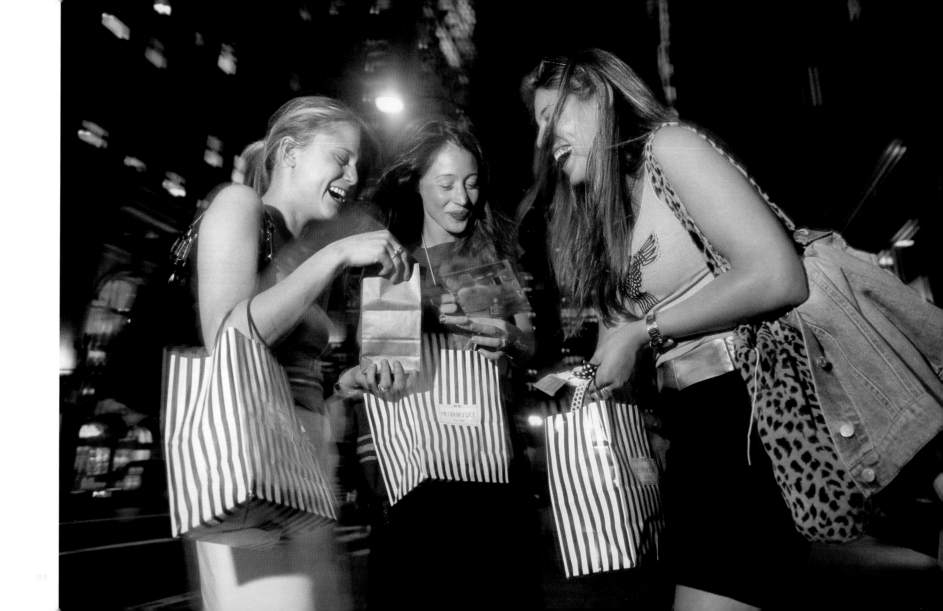

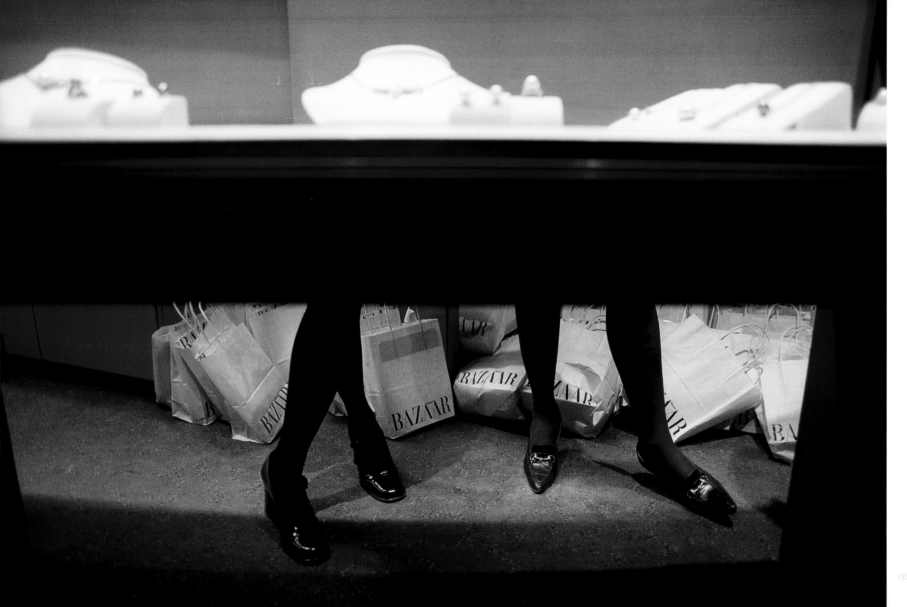

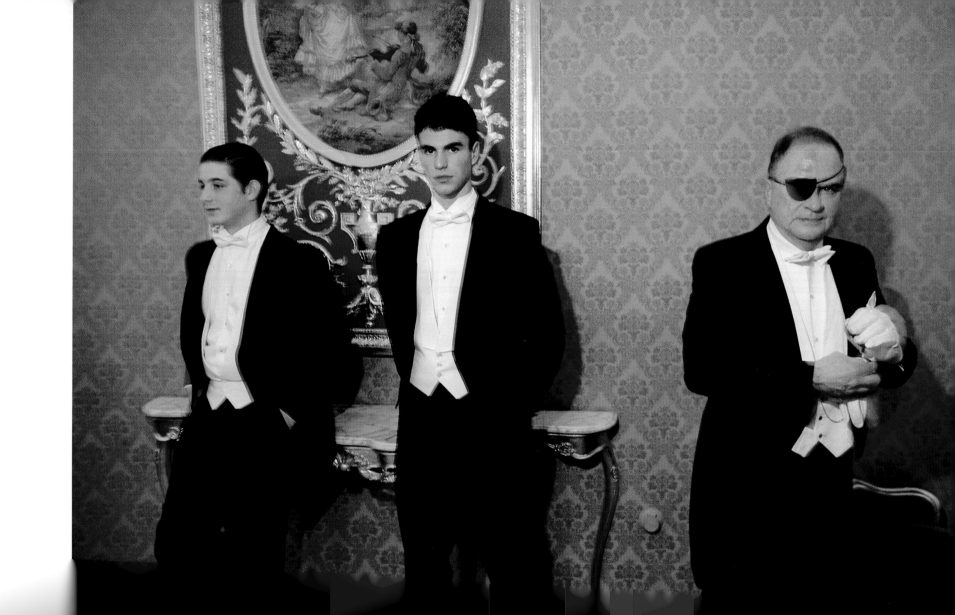

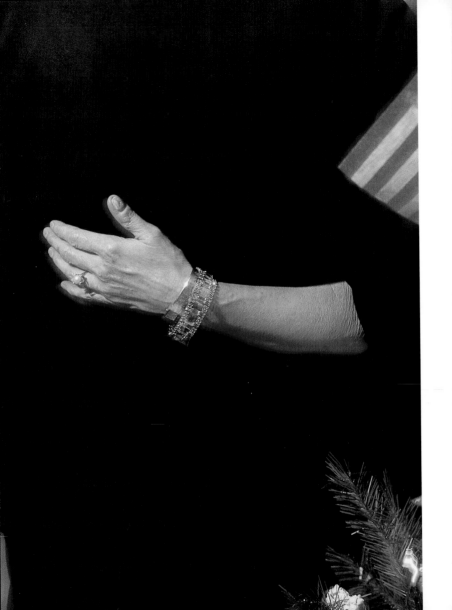
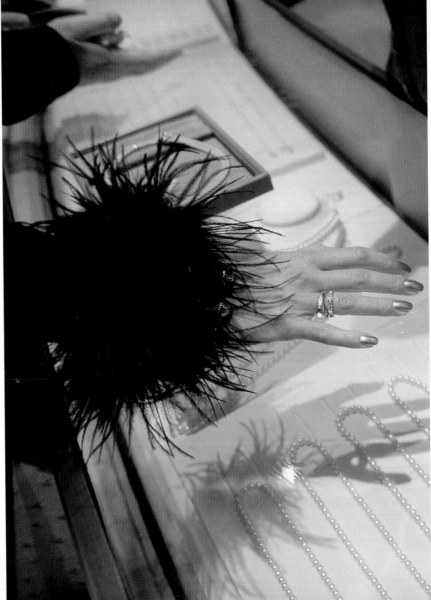

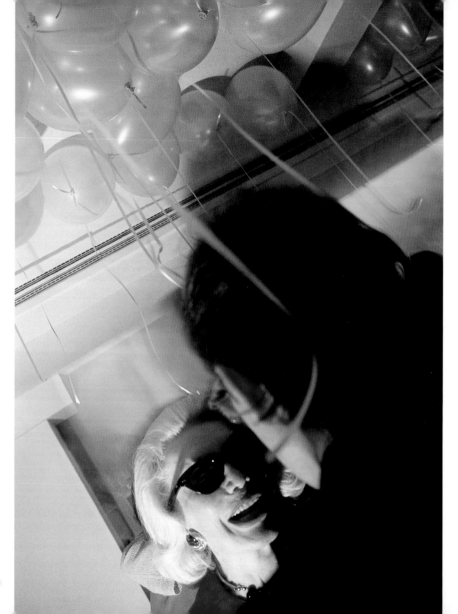

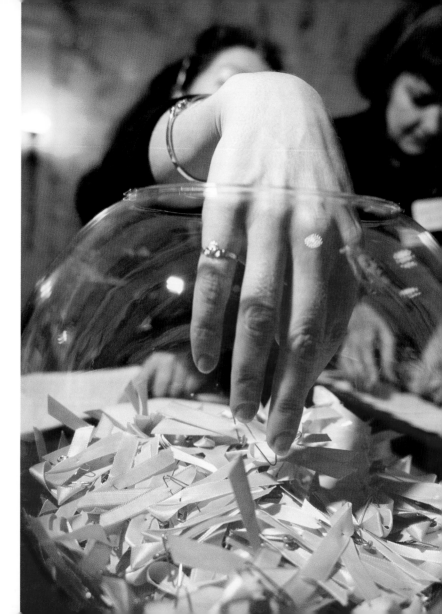

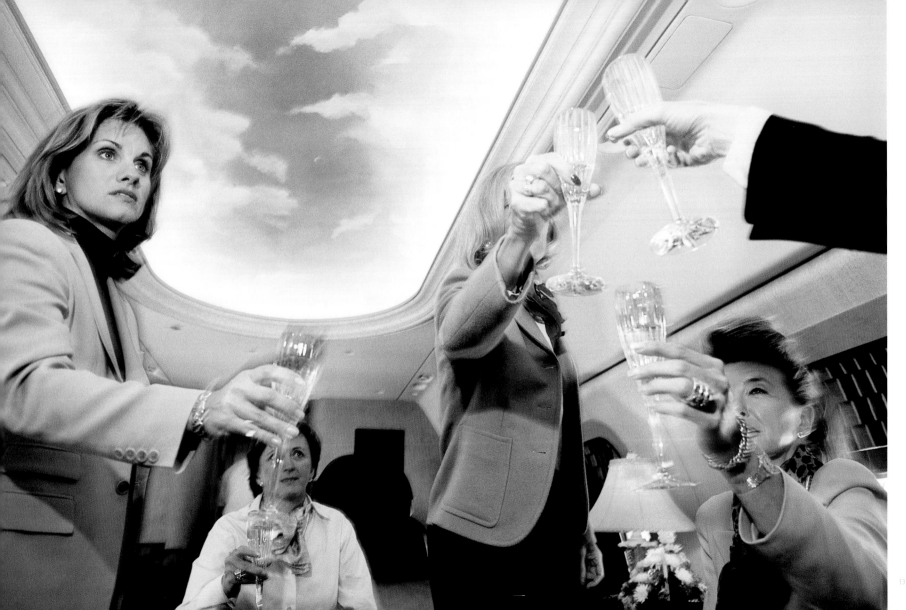

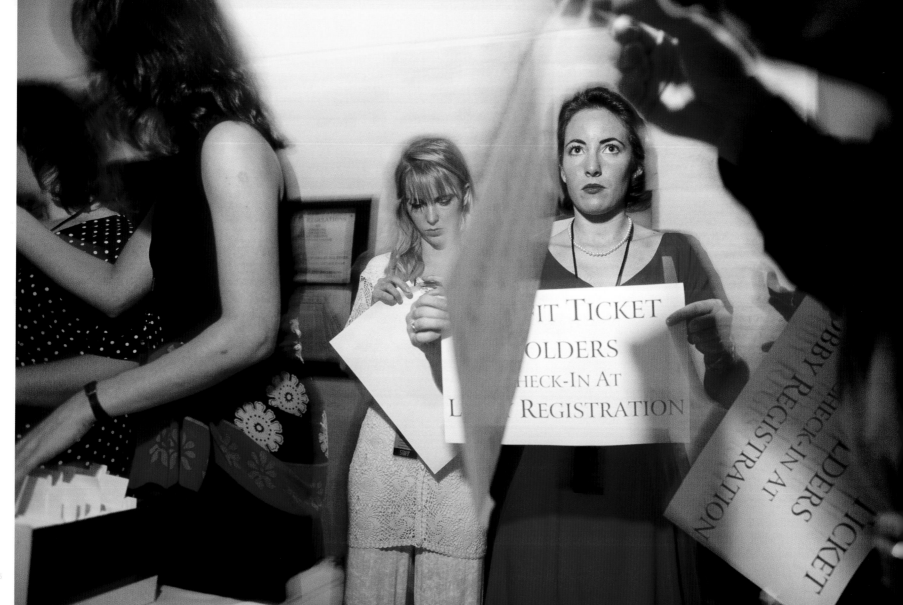

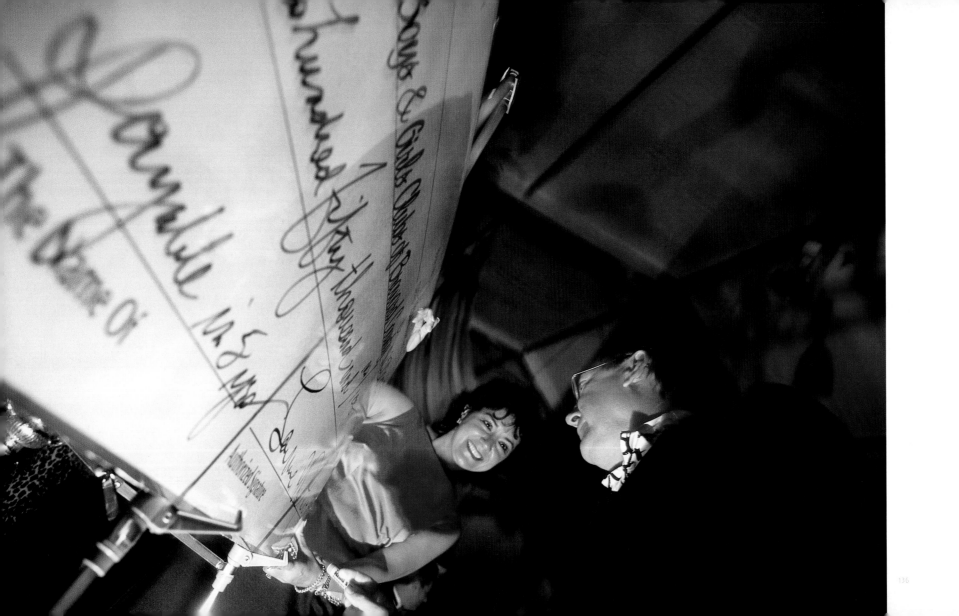

Inheritance: Over the next twenty years, an unprecedented ten trillion dollars will be passed between generations. Never before has so much wealth changed hands.

Percentage of all charitable donations that come from the top 3% of the population: 50

Percentage of Americans willing to switch brands to support a cause when price and quality are equal: 80

Percentage of Americans who believe companies have a responsibility to support causes: 79

Chance that an American household does not give any money to charity: 1 in 10

Chance that an American household donates money to religious or secular organizations: 1 in 2

Average amount American households, who also give to religious causes, donate to charity: $2,247

Average amount American households spend on fully secular charities: $623

Percentage of African-Americans who give to churches: 60

Estimated amount Americans gave to charity in 2002: $240 billion
 Percentage of which comes from individual Americans: 75
 Percentage of which comes from corporate philanthropy: 12

Amount Americans donated to arts and culture in 2000: $3.7 billion

Approximate number of grant-making U.S. foundations: 56,000

Percentage of Americans who volunteered in 2001: 54

Percentage of Americans who volunteer regularly: 25

Percentage of Americans who helped their neighbor with a problem: 77

Percentage of Americans who feel very connected to their communities: 77

Percentage of Americans over 65 who feel disconnected from their community: 14

Percentage of Americans between 18 and 39 who feel disconnected from their community: 33

Percentage of wealthy American men who were motivated to give to charity by tax incentives: 41

Percentage of wealthy women who were motivated to give to charity by tax incentives: 29

Percentage of Silicon Valley millionaires who gave $2,000 or less to charity in 1998: 45

Percentage of Silicon Valley millionaires who said they would donate more when older: 50

Amount Netscape Communications Corp. co-founder, James Clark, gave Stanford University in 1999: $150 million
Amount he withdrew in 2001 after President Bush restricted stem-cell research: $60 million

Cost of a four-week philanthropy workshop run by the Rockefeller Foundation: $10,000

Number of students at Illinois' Aurora University who have earned an academic credit for a course in "business golf": 29

Average amount Americans spend on fast food each year: $500

Average amount Americans spend on charitable donations: $900

Approximate number of charities, nonprofit organizations, and religious congregations in the U.S.: 1.6 million

Amount Americans contributed to charity over the Internet in 2001: $96 million

Rank of direct mail as a resource for Americans to learn about a charity: 1

Number of people investigated for allegedly cheating charities of more than $1 million in aid intended for 9/11 victims: 100

Net worth of Warren E. Buffett in 2003: $36 billion
Percentage given to charity: 1

Amount of cash General Mills gave to charity in 2002: $65 million

Revenue generated by General Mills in 2002: $10.5 billion

Rank of Wal-Mart in total U.S. corporate donations paid in absolute dollars in 2002: 1 ($156 million)

Rank of Ford Motor Company: 2 ($131 million)

Rank of Exxon Mobil Corporation: 5 ($97.2 million)

Amount Nike originally reported to *Business Week* that it gave to charity in 2002: $29.6 million

After catching an error, amount Nike reported it actually gave: $10.2 million

Amount Eli Lilly & Company heiress Ruth Lilly pledged to *Poetry* magazine in 2002: $100 million

Amount Iraq pledged in January 2001 to aid "poor Americans": $93 million

Percentage of Americans living below the poverty line who believe that *"poor people today have it easy"*: 31

Amount the U.S. spent in 1949 on international aid and diplomacy: $66.4 billion

Annual amount that Unilever is required to donate to "social change" as part of their deal to acquire Ben & Jerry's: $1.1 million

Amount of that money donated to the Ruckus Society, which trains activists in civil disobedience, in 2001: $100,000

Estimated number of mink released from a Spanish fur farm in July 2001: 13,000

Estimated number of garden gnomes relocated to the forest since 1996 by France's Gnome Liberation Front: 6,000

CONTENTS

35] Parrish Art Museum gala, the Hamptons, 7/13/96

36] New Yorkers For Children gala, 9/19/01

37] Halloween Masquerade Ball at the Whitney Museum of American Art, 10/31/94

38] Jungle Masquerade benefit for the Rainforest Alliance, the Hamptons, 7/26/00

39] Halloween Masquerade Ball at the Whitney Museum of American Art, 10/31/94

40] Design Industries Foundation Fighting AIDS-Glam Casino night, 5/03

41] Design Industries Foundation Fighting AIDS-Glam Casino night, 5/03

42] (L) Central Park Conservancy Halloween Ball in Central Park, 10/27/99

42] (R) Halloween Ball at the Whitney Museum of American Art, 10/31/94

43] (L) Design Industries Foundation Fighting AIDS-Glam Casino night, 5/03

43] (R) Brooke Astor's 90th birthday party to benefit the New York Landmarks Preservation Foundation, 1992

44] (L) Party at The Metropolitan Museum of Art, 6/23/98

44] (R) Opening night benefit dinner for The Metropolitan Opera, 9/99

45] (L) International Debutante Ball, 12/29/98

45] (R) The Little Orchestra Benefit and Masked Ball, 6/9/99

46] Design Industries Foundation Fighting AIDS-Glam Casino night, 5/03

47] Sheltering Arms Foundation casino night benefit, 11/22/96

48] Hospital benefit, 11/13/96

49] Central Park Conservancy Halloween Ball in Central Park, 10/27/99

50] Fashion Institute benefit at The Metropolitan Museum of Art, 12/8/97

51] Fashion Institute Benefit at The Metropolitan Museum of Art, 12/8/97

52] Leather, Leopard, and Lace Party at Doubles, 3/12/97

53] Benefit in the Hamptons, 6/99

54] Memorial Sloan-Kettering Cancer Center benefit, 10/26/99

55] Colon Cancer Masquerade Ball, 4/03

56] Greyhound Friends Inc. benefit, 3/16/00

57] Humane Society of New York benefit, 5/9/95

58] 100th Anniversary Gala for the Bronx Zoo, 6/3/99

59] 100th Anniversary Gala for the Bronx Zoo, 6/3/99

60] Parrish Art Museum Midsummer Gala, the Hamptons, 7/13/99

79] Party in the Hamptons, 8/97

80] Party in the Hamptons, 9/5/93

81] Hospital benefit, New Jersey, 10/26/96

82] Central Park Conservancy Frederick Law Olmsted Luncheon, 5/7/97

83] Party in the Hamptons, 9/5/93

84] Central Park Conservancy Frederick Law Olmsted Luncheon, 5/7/97

85] Party in California, 6/01

86] Central Park Conservancy Frederick Law Olmsted Luncheon, 5/7/97

87] Brooke Astor on her way to a luncheon, 8/12/91

88] Central Park Conservancy Frederick Law Olmsted Luncheon, 5/3/00

124] Central Park Conservancy benefit, 6/10/99

125] (L) Central Park Conservancy benefit, 6/10/99

125] (R) Benefit for breast cancer research, 10/28/96

126] Party in New York, 10/00

127] Benefit at Lincoln Center for the Performing Arts, 11/95

128] Benefit for the American Foundation for AIDS Research, 6/7/99

129] Benefit for the American Foundation for AIDS Research, 6/7/99

130] Party at a Mikimotto store to benefit breast cancer research, 10/26/99

131] International Debutante Ball, 12/29/94

132] (L) Party for debutantes, 12/28/94

132] (R) Party at a Mikimotto store to benefit breast cancer research, 10/26/99

133] (L) Party in New York, 9/21/00

133] (R) Benefit for breast cancer research, 10/28/96

134] Patrons on a private plane after a benefit in New York, 5/8/97

135] Children's Defense Fund benefit, 11/95

136] Boys and Girls Club of Broward County fund-raiser, 11/99

SPECIAL THANKS

First and foremost I would like to thank Marcel Saba for all he's done in making this book possible. Without him this book would just be a bunch of slides in my closet. I want to thank Carmen Dunjko and Barnaby Marshall for the love and care they put into this publication. Also thanks to Philip Weiss for writing the introduction and for being a great friend, and to Ian Connacher and Chris Turner for all the background research.

A big thanks to Kathy Ryan who jump-started this project and made all these pictures possible when she first sent me to explore this wild and colorful world at the end of the last century.

I would also like to thank Jody Quon, Jean Saba, Chris Doherty, Debbie Bondulic, Shazi, Elizabeth Lagrua, Michelle McNally, Evan Kriss, Armin Harris, Masie Todd, Venita Kaleps, Jocelyn Benzakin, Gad Gross, Janet De Jesus, Margie Goldberg, Ruth Eichhorn, Scott Thode, Beth Flynn, John Francois Leroy, Wilma Simon, Christina Cahill, Leslie Powell, Brian Storm, Mary Ellen Mcgrath, Sarah Harbutt, Joanna Patchner, Neil Stuart, Tom Arndt, Paul Shambroom, Nadja Masri, and Don Standing, who all supported this project.

I want to thank Greta Pratt and Axel and Rose Peterson who have always supported me and were quiet in the mornings, letting me sleep in after all the late-night parties.

CREDITS

Produced by:
Marcel Saba

Text Editing:
Barnaby Marshall

Research:
Ian Conecher
Chris Turner

Book and Cover Design:
Carmen Dunjko
Pod10 Art+Design, Toronto
carmen@pod10.com

Photo Prints:
Shazi at Digizone

Separation Files:
Doug Laxdal
The GAS Company, Toronto

Printing and Binding:
Grafiche d'Auria, Ascoli Piceno

Published by:
powerHouse Books
powerHouseBooks.com

Published in the United States by powerHouse Books,
a division of powerHouse Cultural Entertainment, Inc.
68 Charlton Street, New York, NY 10014-4601
telephone 212 604 9074, fax 212 366 5247
e-mail: actsofcharity@powerHouseBooks.com
website: www.powerHouseBooks.com

First edition, 2004

Library of Congress Cataloging-in-Publication Data:

Peterson, Mark, 1955-
 Acts of charity / photographs by Mark Peterson ; text by Philip Weiss.-- 1st ed.
 p. cm.
 ISBN 1-57687-211-4 (hardcover)
 1. Charities--New York (State)--New York. 2. Fund raising--New York (State)--New
York. 3. Philanthropists--New York (State)--New York--Social life and customs--Pictorial
works. 4. Upper class--New York (State)--New York--Social life and customs--Pictorial
works. 5. Socialites--New York (State)--New York--Pictorial works. 6. Parties--New York
(State)--New York--Pictorial works. I. Weiss, Philip. II. Title.

 HV99.N59P44 2004
 361.7'63'097471--dc22

 2004044717

Hardcover ISBN 1-57687-211-4

Book and cover design by Carmen Dunjko

A complete catalog of powerHouse Books and
Limited Editions is available upon request;
please call, write, or donate your time to our website.

10 9 8 7 6 5 4 3 2 1

Printed and bound in Italy